CHICAGO

Unforgettable Vintage Images of an All-American City

Note from the Publisher

Since the publication of the first edition of
Chicago: Unforgettable Images of an All-American City, Arcadia has
joined the National Trust as a corporate partner. Royalties from the
sale of this book and the others in the *Best of Series* will be donated to
the National Trust for Historic Preservation. These funds will be used
to further their work and provide support to the preservation
movement nationwide.

For further details, please contact us at Arcadia's Midwest office.

CHICAGO

Unforgettable Vintage Images of an All-American City

ARCADIA

Copyright © 2000 by Arcadia Publishing.
ISBN 0-7385-0723-7

First Printed 2000.
Reprinted 2001.

Published by Arcadia Publishing,
an imprint of Tempus Publishing, Inc.
3047 N. Lincoln Ave., Suite 410
Chicago, IL 60657

Printed in Great Britain.

Library of Congress Catalog Card Number: 00-104062

For all general information contact Arcadia Publishing at:
Telephone 843-853-2070
Fax 843-853-0044
E-Mail sales@arcadiapublishing.com

For customer service and orders:
Toll-Free 1-888-313-2665

Visit us on the internet at http://www.arcadiapublishing.com

CONTENTS

ACKNOWLEDGMENTS

Arcadia Publishing would like to thank the following authors and historical organizations. Your words and images have truly captured our hearts.

Frank Beberdick, *Chicago's Historic Pullman District*
Fred W. Beuttler, *The University of Illinois at Chicago*
Dominic Candeloro, *Chicago Heights, Italians in Chicago*
Charles Celander, *Chicago's South Shore*
Dick Clark, *Black Baseball in Chicago*
Jim Edwards, *Aurora, Elgin*
Wynette Edwards, *Aurora, Elgin, St. Charles*
Mary GiaQuinta, *Flossmoor*
Paul M. Green, *A View from Chicago's City Hall*
Melvin G. Holli, *A View from Chicago's City Hall, University of Illinois at Chicago*
Elise D. Kabbes, *Flossmoor*
Larry Lester, *Black Baseball in Chicago*
Raymond Lohne, *German Chicago: The Danube Swabians and the American Aid Societies*
Kenneth Luostari, *Midwest Skiing: A Glance Back*
Sammy J. Miller, *Black Baseball in Chicago*
Robert Mueller, *La Grange and La Grange Park*
Roseanna Mueller, *La Grange and La Grange Park*
Dominic A. Pacyga, *Chicago's Southeast Side*
Barbara Paul, *Chicago Heights*
Marilyn Pedersen, *Palatine*
John Pontti, *Midwest Skiing: A Glance Back*
Robert V. Remini, *The University of Illinois at Chicago*
Alice Rosenberg, *Palatine*
Rod Sellers, *Chicago's Southeast Side*
David M. Sokol, *Oak Park*

Aurora Historical Society
Elgin Area Historical Society
Flossmoor Public Library
Historic Pullman Foundation
Historical Preservation Advisory Committee (Chicago Heights)
James P. Fitzgibbons Historical Museum
Italian American Collection, Special Collections Division, University of Illinois at Chicago Library
Italian Cultural Center
La Grange Area Historical Society
Palatine Historical Society
Southeast Historical Society
St. Charles Heritage Center

INTRODUCTION

Come and show me another city with lifted head singing
so proud to be alive and coarse and strong and cunning.

—*from* Chicago *by Carl Sandburg*

When the Great Chicago Fire of 1871 leveled a good part of the city, it didn't take long for the rebuilding to begin. The city quickly became an experiment in new technologies and engineering prowess, becoming the home of the first "skyscraper," the nine-story Home Insurance Building in 1885. With the succession of great buildings and architectural firsts, Chicago became the "City of the Big Shoulders," as native son Carl Sandburg would later declare.

The history of the city goes back much further. The marshland along this particular stretch of Lake Michigan (known as "checagou", meaning "wild onion", by the Native Americans living here) had been visited by the French explorers Père Marquette and Louis Jolliet in the middle of the 17th century. But it was in 1779, when a Haitian of African descent named Jean Baptiste Point DuSable established a trading post on the north bank of the Chicago River, that the city we know as Chicago was born.

When the bidding was opened for the right to host the World's Fair of 1892, which was intended to celebrate the 400th anniversary of the voyage of Christopher Columbus, the politicians and captains of industry sent delegations to lobby for Chicago. The aim was to show off the "new" Chicago; to demonstrate how the city had recovered from the Great Fire twenty years prior. Eventually, Chicago did win the bid, and the Columbian Exposition was held in the city (although delays kept the Exposition from opening until 1893). The delegation was so persistent in their boosterism that a New York newspaperman dubbed them as coming from "that windy city." And since that day, Chicago is best known as just that. (It should be noted that according to a recent study Chicago is not the windiest city in the U.S. There are actually about 40 other cities in the country that are windier).

Chicago has long been known as the "Second City," although in reality it is the third city population-wise since Los Angeles overtook Chicago. But to the citizens of this truly American of cities, it is first in their hearts. And Chicago is a city of firsts—the first skyscraper (mentioned above), the first Ferris Wheel (at the Columbian Exposition), and

one of the first public zoos (the Lincoln Park Zoo, now one of the last free zoos in the country). There is an energy in this city that demands the biggest, the tallest, and the most. Until recently, Chicago had the world's tallest building (and there are those that will argue that the other building in Malaysia cheated by putting towers on top!) But if current plans for a new "world's tallest" are adopted, Chicago may soon regain the title. As it is, the city does have three of the tallest buildings in the world: the Sears Tower (1454 feet), the Amoco Building (1136 feet), and the John Hancock (1127 feet).

Today, Chicago is a world-class city that attracts tourists from all over the world. Whether they come to see the living architecture museum that is Chicago's Loop, the genius of Frank Lloyd Wight in nearby Oak Park, the abundance of fascinating museums, the incomparable Chicago Symphony Orchestra, the magnificent Art Institute of Chicago (which boasts the largest collection of Impressionist paintings outside of the Louvre in Paris), or the hundreds of festivals that enliven the city, they will never forget Chicago, "that toddlin' town," and perhaps will remember it as "my kind of town."

<div align="right">

Tom Rakness
Editor, Arcadia Publishing

</div>

Chicago today, by the numbers:

- 46 museums
- More than 200 theatres
- About 7000 restaurants
- 77 neighborhoods
- 29 miles of lakefront (15 of those for bathing)
- More than 200 annual parades
- The world's largest public library, the Harold Washington Library Center, holding two million books

(Source: City of Chicago Department of Cultural Affairs, Chicago Office of Tourism)

I

CITY OF NEIGHBORHOODS

PEOPLE AND PLACES

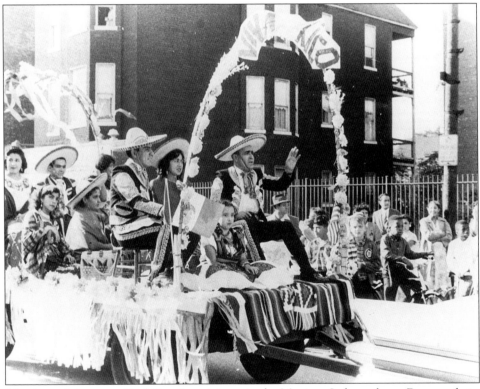

Members of the group "Del Coro" participate in the Mexican Independence Day parade in South Chicago on September 15, 1957. They are dressed in Mariachi apparel to reflect their Mexican heritage. The South Chicago Mexican community is one of the oldest in the city of Chicago. South Chicago's Mexican Independence Day celebration continues to be a much-anticipated local event. (*Chicago's Southeast Side*)

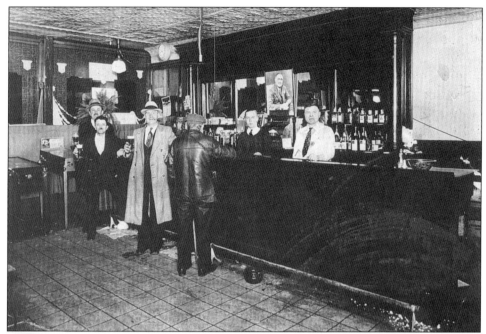

Kurnik's Tavern served the Hegewisch neighborhood from a location at 13200 Houston Street. Many different types of taverns operated in the area. Some catered to particular ethnic groups. Some were largely "men only" establishments, while others were "stand up establishments" as shown here. Kurnik's stood across the street from another neighborhood institution, St. Florian's Polish Roman Catholic Church. (*Chicago's Southeast Side*)

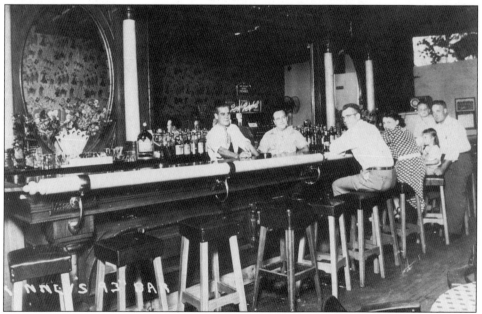

Kinney's Marble Rail Bar served customers at 92nd and South Chicago Avenue. Neighborhood taverns often catered to families. (*Chicago's Southeast Side*)

Polish Catholic steelworkers established the first Polish congregation, Immaculate Conception, on the Southeast Side, in 1882 as an ethnic parish. Eventually, four Polish Catholic parishes served the large Polish community of South Chicago. Pictured here is the ornate Marian altar of the church located at 88th and Commercial Avenue. (*Chicago's Southeast Side*)

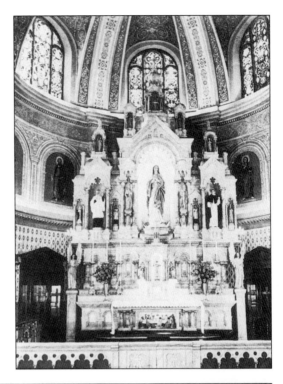

This midnight Mass was held at St. Michael Archangel on Christmas Eve, 1982. St. Michael's conducts services in Polish, Spanish, and English to accommodate the changing ethnic makeup of the parish. (*Chicago's Southeast Side*)

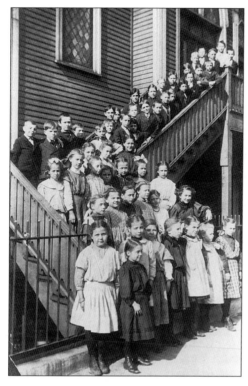

Virtually every Catholic parish on the Southeast Side had an elementary school. Many Catholics felt that Protestants dominated the public schools, so Catholic schools also served the particular ethnic group who attended that parish. The 1910 class of SS. Peter and Paul Parish pose for a class photo. The school opened on November 25, 1882, and served the predominantly German Catholic community of South Chicago. (*Chicago's Southeast Side*)

The Bacilio Hernandez and Paula Hernandez-Valencia family was one of the first families of Mexican descent to live in South Deering. This portrait was taken about 1942. The children pictured are (not in order) Harold, Rose, Augustine, Amelia, Leonard, Mary, and Thomas. (*Chicago's Southeast Side*)

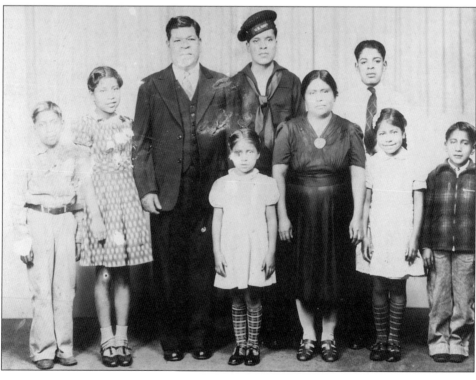

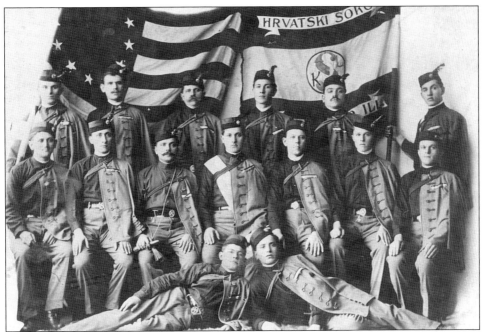

Ethnic groups formed various fraternal, cultural, and patriotic organizations on the Southeast Side. Many of these groups patterned themselves on the German Turnverein societies. The Hrvatski Sokol (Croatian Falcons) met in Croatian Hall at 96th and Commercial Avenue. Sokol members believed in physical fitness and patriotism. (*Chicago's Southeast Side*)

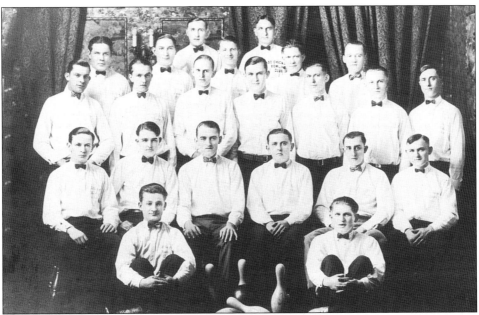

On the Southeast Side, bowling developed as a popular local sport. Many bowling alleys in the various neighborhoods supported the different leagues and teams. The South Chicago Bowling Club was one of the oldest bowling organizations in Illinois. (*Chicago's Southeast Side*)

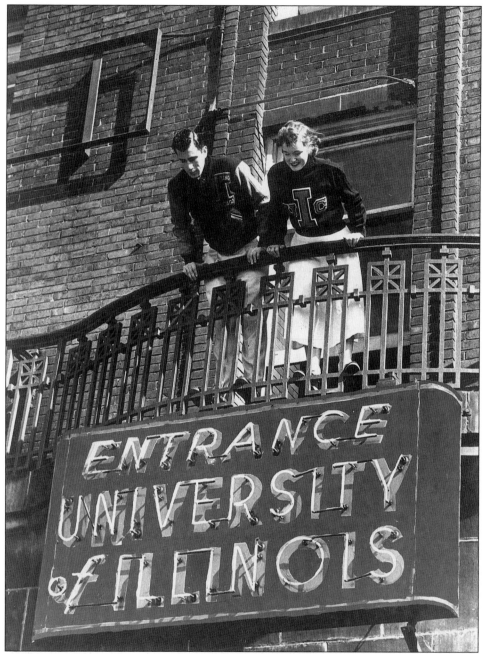

Chicago Undergraduate Division (CUD) students Howard Grosky and Mary Meixer from the University of Illinois at Chicago lean from the balcony above the Navy Pier entrance in 1954. Unlike the Navy, which used the Pier for training purposes in WWII, the University only occupied part of the Pier, which became an increasing problem due to student enrollment pressures. Other tenants included the Chicago Police Department's traffic division, the North Pier Terminal Company, and several military detachments. (UIC photograph by Thomas Fehr.) (*University of Illinois-Chicago*)

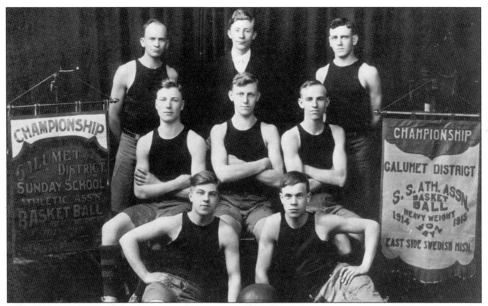

Churches and ethnic organizations sponsored many sports teams. This is a team picture of the Calumet District Sunday School Athletic Association heavyweight basketball champions in 1914–15, who were sponsored by the East Side Swedish Mission. Churches often used athletic teams to encourage regular church attendance and participation by younger members of the congregation. (*Chicago's Southeast Side*)

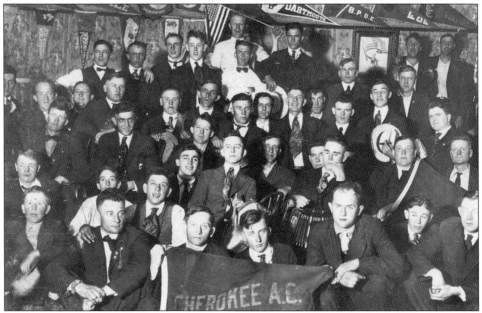

The Cherokee Athletic Club was another East Side institution. Athletic clubs, which were very popular in Chicago, were often referred to as social and athletic clubs, or SACs. They grew out of children's play groups or from gangs. In many parts of the city they played important roles in local political organizations. (*Chicago's Southeast Side*)

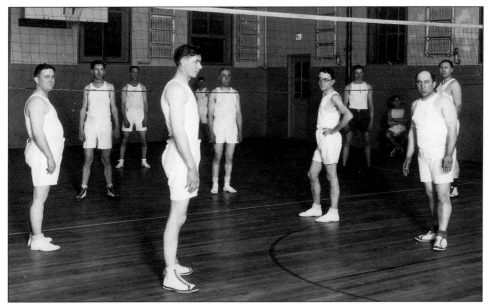

German Baptists organized the South Chicago YMCA on May 15, 1882. After being located at several sites in the community and then closing for a while due to financial difficulties, a permanent South Chicago facility opened on November 6, 1926. The "Y" offered rooms, Americanization classes, and both social and athletic activities. Here, volleyball players enjoy a game in the YMCA gymnasium. (*Chicago's Southeast Side*)

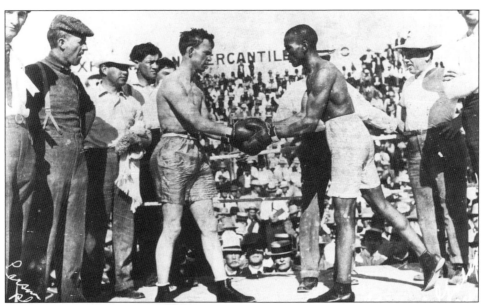

On occasion, a neighborhood boxer moved on to a high profile professional career. "Battling Nelson," also known as the "Durable Dane," came from Hegewisch. Nelson appears here preparing for a fight against Joe Gans in Nevada in 1906. Nelson lost the fight on a foul in the 42nd round. Two years later, he won the world lightweight title by knocking out Gans twice in two months. (*Chicago's Southeast Side*)

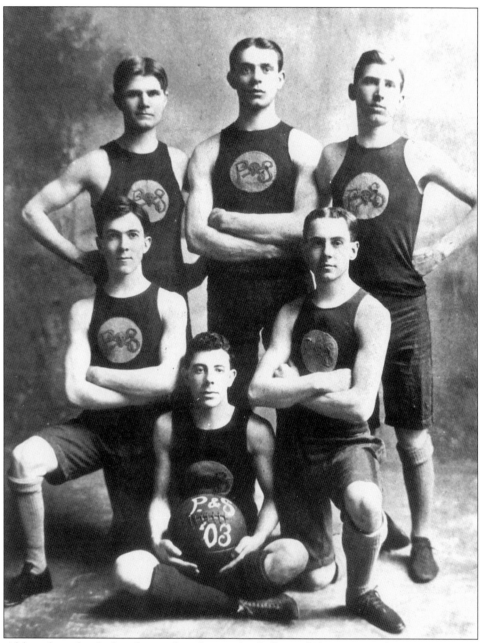

Although a school of professional medicine, the College of Physicians and Surgeons at UIC featured an active student body that eagerly participated in a wide array of activities, including intercollegiate athletics. Pictured here is the P&S Basketball team of 1903. (UIC Library of Health Sciences.) (*University of Illinois-Chicago*)

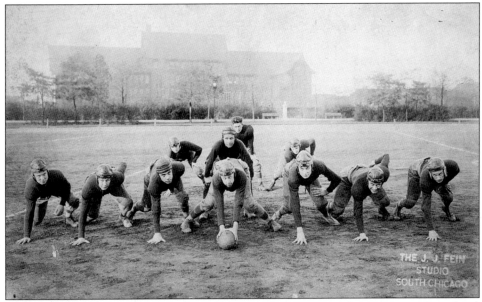

The 1917 Bowen football team lines up in a "T" formation. According to the school yearbook, *The Bowen Prep*, the 1917 season was a very successful one. Bowen's lightweight division football team lost 15-14 in the city championship game against North Side rival Senn High School. (*Chicago's Southeast Side*)

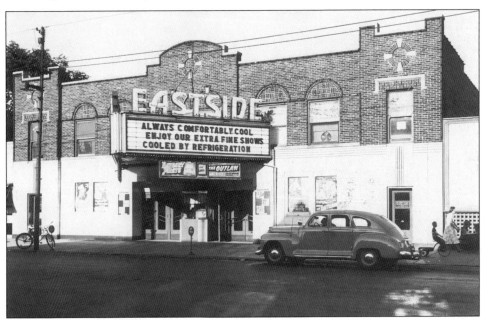

The East Side Theater operated at 105th and Ewing Avenue. This 1950 view advertises the air conditioned comfort of the theater. In the days before it became commonplace, many early movie theaters were the only places where area residents could enjoy air conditioning. Entrepreneurs built the theater in the mid-1920s. It was one of the first in the city to be converted to "talkies" later that decade. (*Chicago's Southeast Side*)

The Gayety Theater and Ice Cream and Candy Store was a neighborhood landmark located at 9211 South Commercial Avenue. As the Mexican community in the area grew, the Gayety changed its format to offer Spanish language films. James Papageorge, a Greek immigrant who came to the United States in 1904, founded Gayety's Candies and Ice Cream. The theater burned down in 1982 and the ice cream and candy store continued its business in the suburb of Lansing, Illinois. (*Chicago's Southeast Side*)

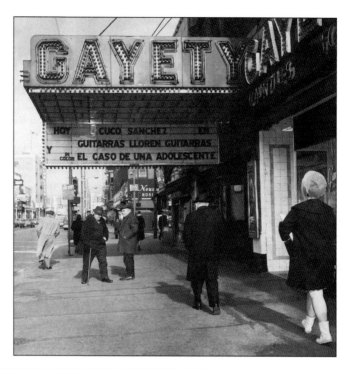

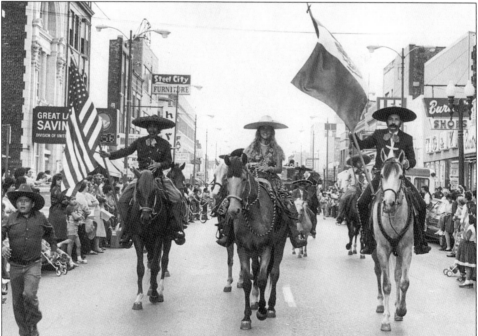

Mexican equestrians ride in a parade on 91st and Commercial Avenue in 1982. Ethnic celebrations like Mexican Independence Day and Cinco de Mayo were popular events not only with the Mexican community, but also with other ethnic groups in the community. (*Chicago's Southeast Side*)

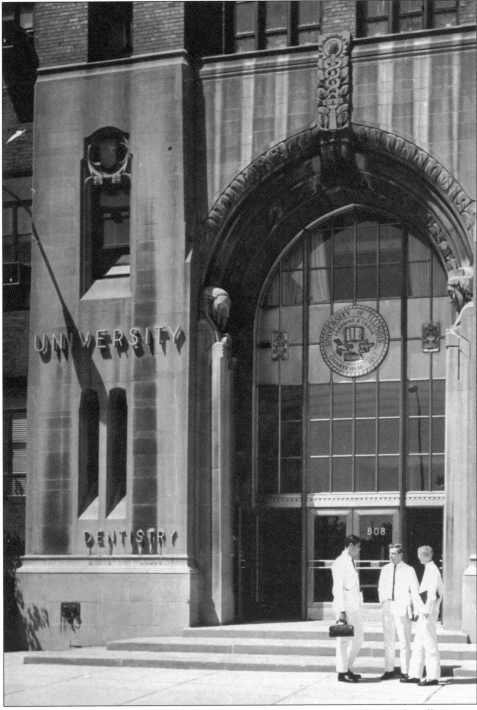

Pictured here in the early 1950s is the entrance to UIC's professional colleges, as represented by the three major colleges: dentistry, medicine, and pharmacy. (University of Illinois at Urbana-Champaign.) (*University of Illinois-Chicago*)

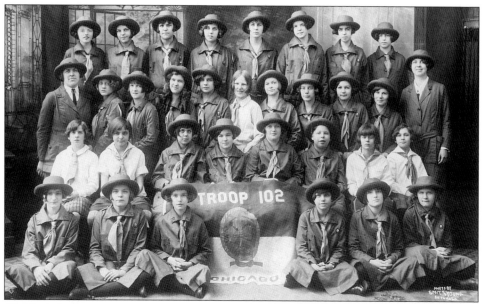

Children had an opportunity to join community organizations. Pictured here is the East Side First Evangelical Church Girl Scout Troop 102, one of the oldest troops in the community. Local churches sponsored most scout troops. (*Chicago's Southeast Side*)

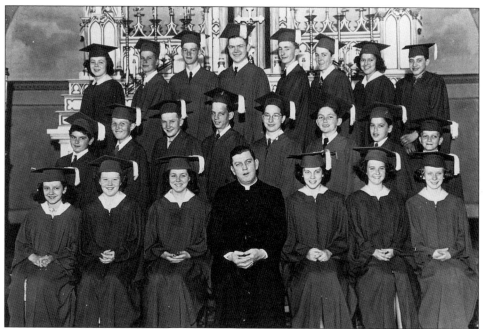

St. Patrick's Church established an elementary school to serve its predominantly Irish population, and also opened a high school in 1889. It was the first Catholic coeducational parish high school in the city of Chicago. In 1924, the high school consolidated with Mercy High School. This is the 1949 graduation class of St. Patrick's Grammar School. (*Chicago's Southeast Side*)

Millie, Ray, Connie, and Henry Dolatowski were children of Polish immigrants. Family ties were very important to many of the ethnic groups on the Southeast Side and often included the extended family. Many times, one family member would come to the States and begin saving passage money for other members, sending for them one by one until the entire family lived in America. (*Chicago's Southeast Side*)

This photograph of a family picnic at 110th Street in 1900 shows the rural nature of much of the East Side at the time. Later, single family homes covered the area. (*Chicago's Southeast Side*)

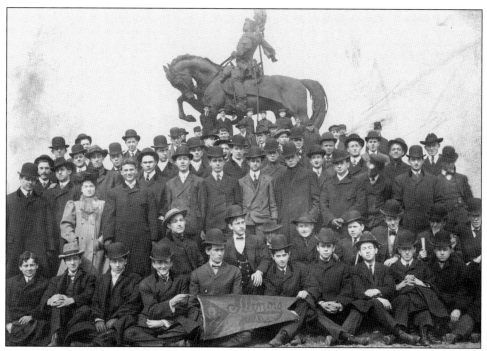

UIC's Pharmacy's class of '06, posing for their junior class picture in front of General Logan's statue in Chicago's Grant Park. Note the "Illinois Pharmacy" pennant with skull and crossbones. (Courtesy of College of Pharmacy.) (*University of Illinois-Chicago*)

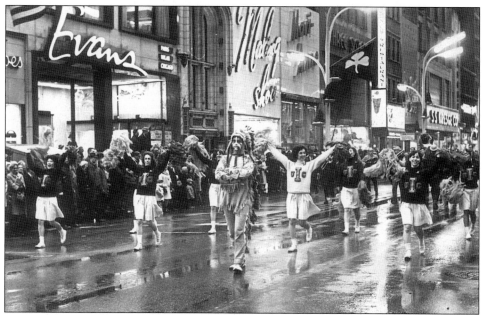

Participants march in Chicago's St. Patrick's Day Parade, 1965. Circle Campus had opened only a few weeks before, but the band still was able to march behind the Chief and the cheerleaders, with their UIC letters. (UIC.) (*University of Illinois-Chicago*)

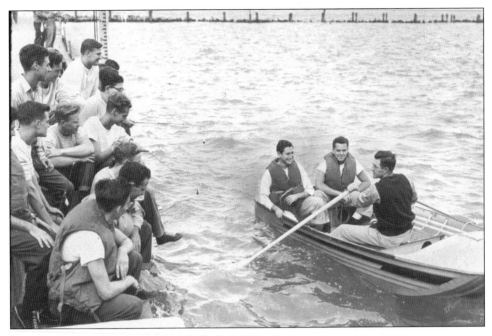

Physical education often had to be imaginative in its use of space. Pier faculty, such as Leo Gedvilas (with oars) taught swimming, boating, and fishing in the lake, and other instructors used Chicago's park system for outdoor archery classes. (UIC photographs by Thomas Fehr.) (*University of Illinois-Chicago*)

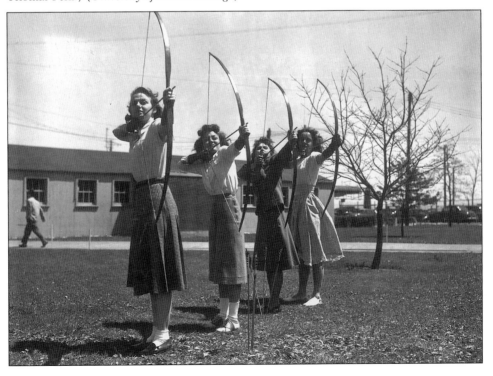

This crowd is gathered to pose in front of St. Alphonsus Catholic Church on Lincoln and Wellington, on August 20, 1961. (*German Chicago*)

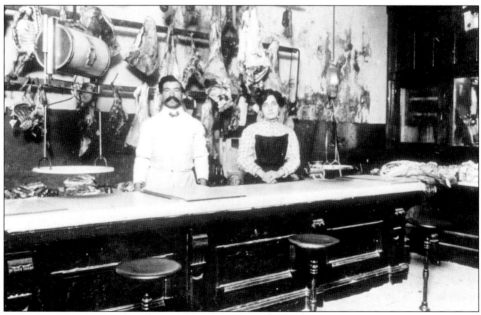

Proud proprietors stand in front of their stock of fresh meat. Italian Americans have been prominent in Chicago in small family businesses since the 1920s. Food stores and meat markets provided regional specialities to customers in the reconstituted villages that became Italian neighborhoods. (*Italians in Chicago*)

25

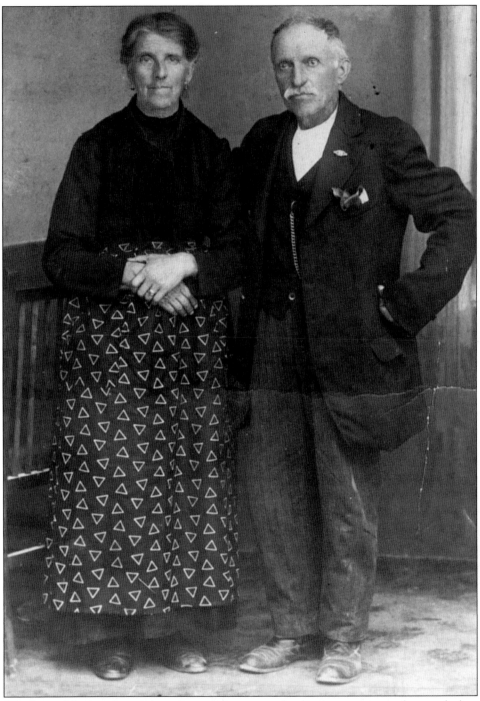

The faces of the immigrants in early portraits express the dignity, purpose, and strength that allowed them to cope with and eventually thrive in their new environment. (Photo from the Italian-American Collection, Special Collections Division of the UIC Library.) (*Italians in Chicago*)

In the 1970s the Villa Scalabrini Home for the Aged held a Mortgage Burning Gala at the Auditorium Theatre, featuring Frank Sinatra, Tony Bennett, and Father Armando Pierini, a leader of the Italian-American community. (*Italians in Chicago*)

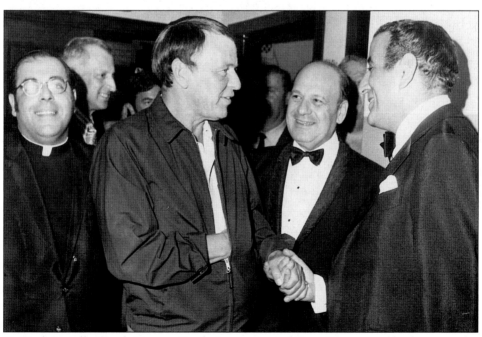

Fr. Paul Asciolla, Frank Sinatra, Frank Annunzio, and Tony Bennett are backstage at the Mortgage Burning Gala. (*Italians in Chicago*)

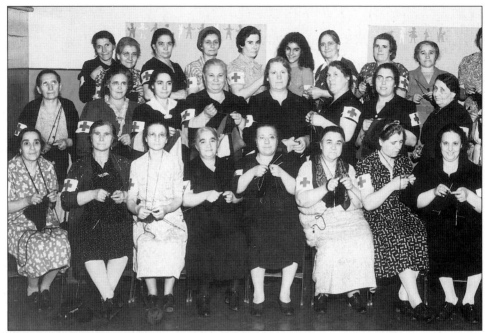

Italian-American women in the Columbus Park Field House during WW II met under the auspices of the Red Cross to knit socks and other items for the soldiers. Such activities produced the needed items, and they involved the civilian populace more directly in the war effort. (*Italians in Chicago*)

Spectators watch the Columbus Day Parade. (*Italians in Chicago*)

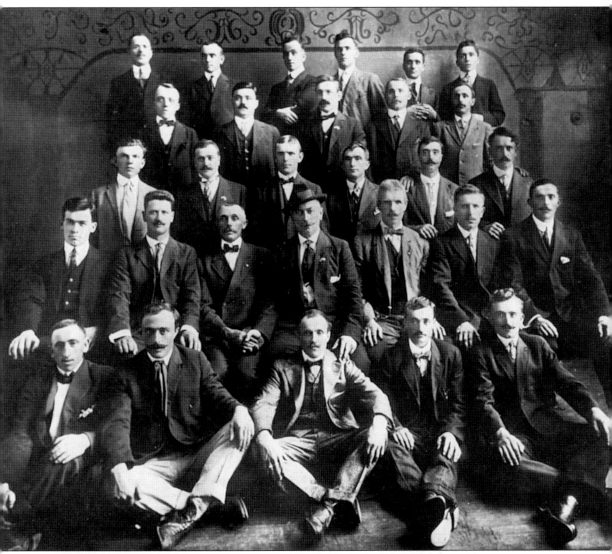

The Circolo Vicentinese from Roseland gathered for this 1925 photograph. Though most Chicago Italians had southern origins, many Roseland Italians hailed from the area around the Altopiano Asiago. (Italian-American Collection.) (*Italians in Chicago*)

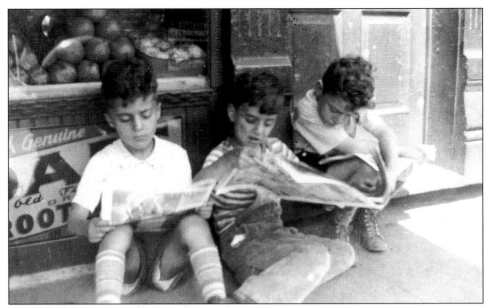

Three boys read the comics and the sports pages in front of a "Dad's Old Fashioned Root Beer" sign. This photograph conveys the attractiveness and power of nostalgia for the "old neighborhood," an almost universal sentiment of first and second generation folks who moved to the suburbs. (Italian-American Collection.) (*Italians in Chicago*)

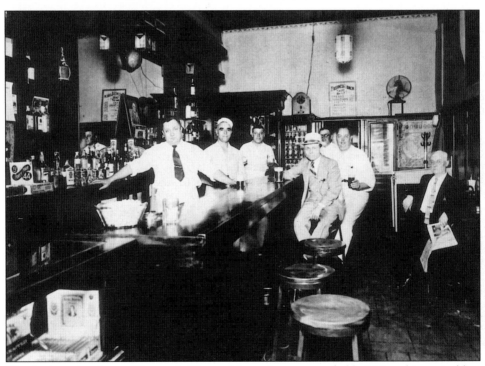

The business lunch was 25¢, steak 35¢, and frosty beer was probably 10¢ at this typical bar in the 1930s. (*Italians in Chicago*)

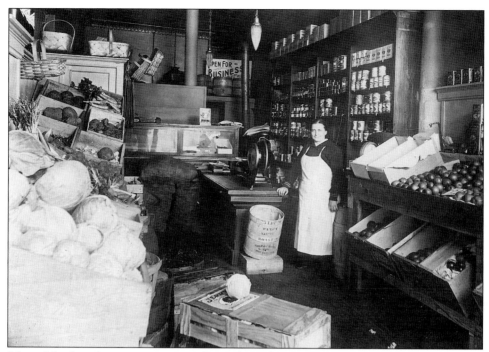

Maria Marchetti's grocery store was located on the Near West Side. It is shown here in 1915. (*Italians in Chicago*)

Mancinelli family members are shown in front of their Near West Side watch repair and jewelry shop in 1911. This photograph provides strong evidence of a class of small business owners early in the century. (*Italians in Chicago*)

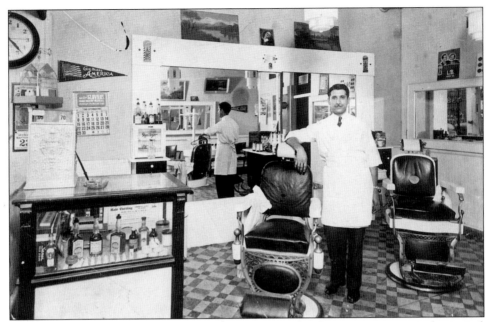

"At your service!" Tom Scalia represents a generation of Italian-American men who moved up from working class to small business as neighborhood barbers. The shop was located at 438 West Thirty-first Street in the 1940s. Into the 1960s, the Barbers' Union was mostly Italian American. (Italian-American Collection.) (*Italians in Chicago*)

The Pullman Company office building designed by architect Solon S. Beman, at Michigan Avenue and Adams Street, was constructed in 1884 across the street from the Art Institute. This was where George Pullman and the executive officers of the Pullman Company were located. The upper floors contained some of the more fashionable apartments in Chicago. It also contained the Tip Top Inn, once frequented by George M. Cohan. The building was demolished in 1956. (Courtesy of South Suburban Genealogical and Historical Society.) (*Chicago's Historic Pullman District*)

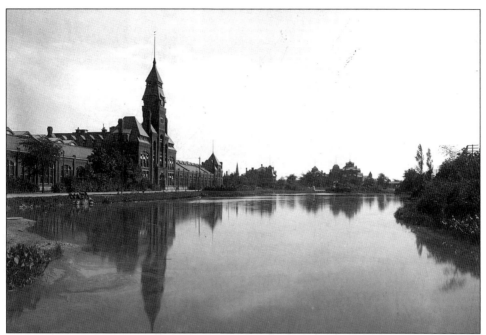

The administration building and erecting shops of the Pullman Company are shown on the left in 1887. Lake Vista, a decorative pond used to provide cooling water to condense the exhaust steam from the Corliss engine, is in the foreground. This photograph, looking south, shows the Florence Hotel in the left background and the Arcade building in the center. (*Chicago's Historic Pullman District*)

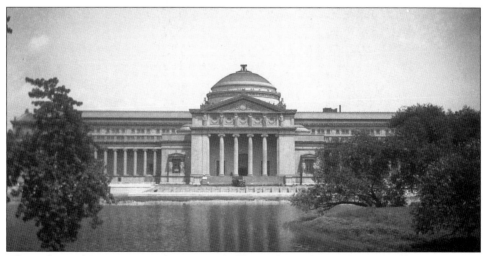

The Palace of Fine Arts at the 1893 World's Fair was designed by Charles B. Atwood. Concerned for the safety of the artworks installed within, it was one of the few buildings constructed of brick, and thus fireproof. The majority of the fair's buildings were constructed with staff—a mixture of plaster, cement, and jute fiber. The Palace of Fine Arts pictured here in 1938 would later become the Museum of Science and Industry. (*Chicago's South Shore*)

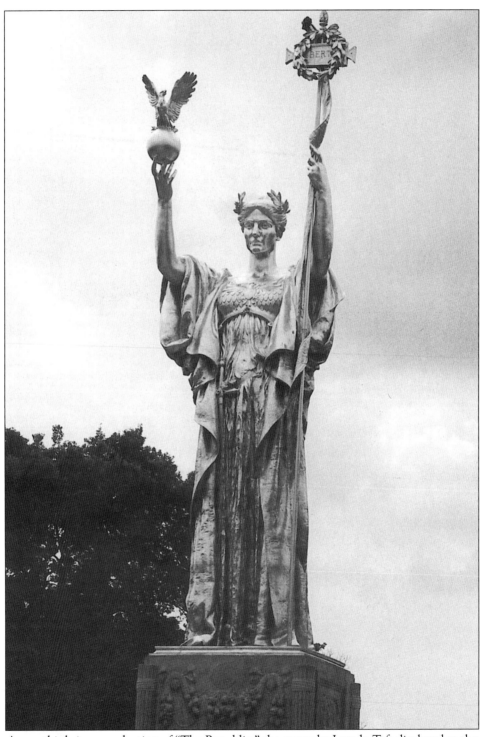

A one-third-size reproduction of "The Republic," the statue by Lorado Taft displayed at the Exposition, now stands in Jackson Park near the site of the original. (*Chicago's South Shore*)

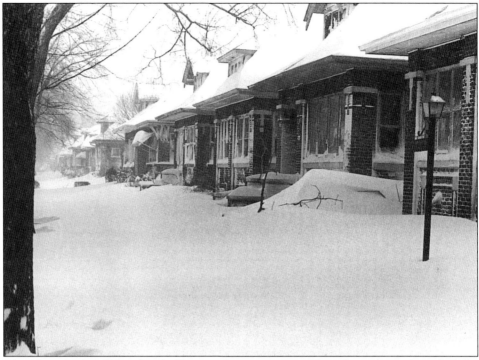

The blizzard of 1967 hit South Shore with a vengeance. These bungalows along Oglesby Avenue were buried on January 30, 1967. (*Chicago's South Shore*)

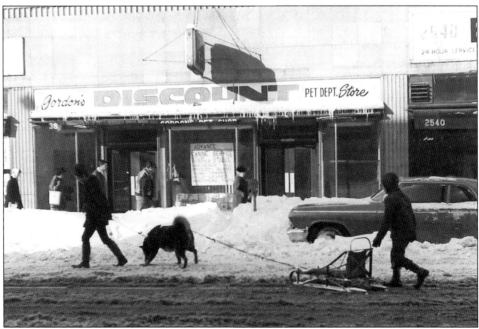

Seventy-ninth Street, between Kingston and Colfax Avenues, was best left to the (sled) dogs. Perhaps it is appropriate that Gordon's Pet Shop is in the background. (*Chicago's South Shore*)

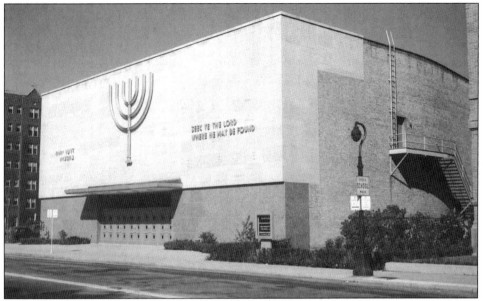

Around the turn of the century, a Jewish tailor named Furzinsky reportedly had a shop near 79th Street and Exchange Avenue. It would be more than 20 years later before the community would have its own synagogue. In the early 1920s, Jews from Washington Park began moving in greater numbers to South Shore, and in 1928, the South Shore Temple was founded. Dr. George Fax was the first rabbi, and Louis Kahn headed the congregation of 150. This photograph shows the South Shore Temple at 7215 Jeffery Boulevard in 1954. (*Chicago's South Shore*)

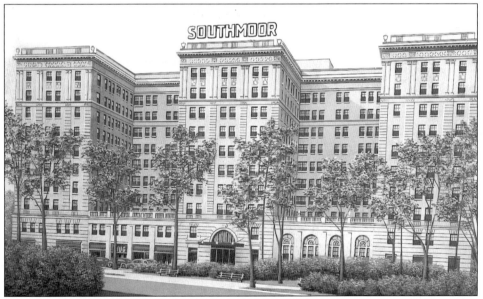

The Southmoor Hotel was built on Stony Island Avenue overlooking Jackson Park in 1924. The grand building was later turned into apartments, before eventually being torn down. (*Chicago's South Shore*)

The First Presbyterian Church promoted an image of integration and unity in the late 1950s. (*Chicago's South Shore*)

The Reverend H. William Barks Jr., along with unidentified members of St. Margaret's Episcopal Church, watch as their Episcopal bishop performs a 1955 groundbreaking ceremony. (*Chicago's South Shore*)

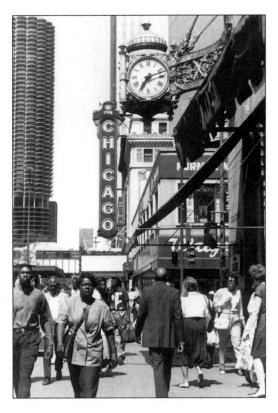

State Street, Chicago's "Great Street," hit on hard times in the late 1970s and early 1980s. In order to revive the street, a State Street Mall was created, and all automobile traffic was abolished. The plan was unsuccessful. Today, State Street has returned to its traditional hustle and bustle of automobile and pedestrian traffic. Shown here is the famous Chicago Theater Marquee. (Courtesy City of Chicago, Graphics and Reproduction Center.) (*A View from Chicago's City Hall*)

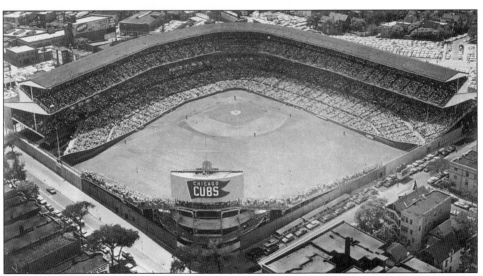

What could be better than spending an afternoon at Wrigley Field? How about going to a game and finding yourself witness to a pitching duel between Hall-of-Famer Satchel Paige and the best black southpaw of the forties, Verdell "Lefty" Mathis of the Memphis Red Sox. Under the title "Satchel Paige Day," this historic matchup occurred twice; once in 1942 and again in 1943. (Courtesy of NoirTech Research Inc.) (*Black Baseball in Chicago*)

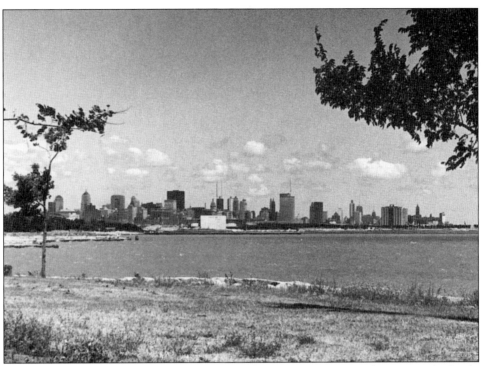

This is the skyline as it appeared from the south side in the 1960s. (*Chicago's South Shore*)

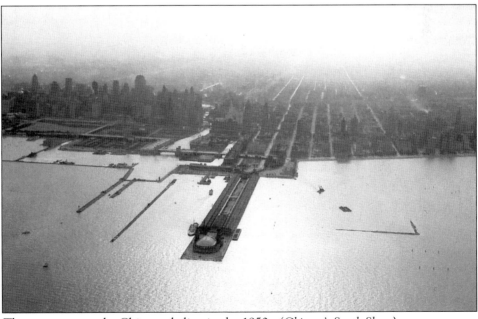

The sun sets over the Chicago skyline in the 1950s. (*Chicago's South Shore*)

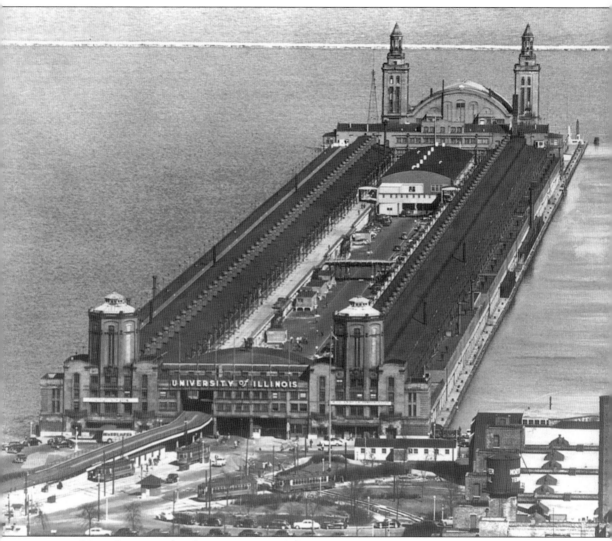

Navy Pier, completed in 1916, extended 3,000 feet eastward into Lake Michigan. The University of Illinois at Chicago leased the north half of the Pier in 1946 as a temporary facility to accommodate students on the G.I. Bill. Students enjoyed the college's lake location and "algae-covered walls," nicknaming the campus "Harvard on the Rocks." (*University of Illinois-Chicago*)

This is another view of the new and improved Navy Pier with its imposing Ferris Wheel.
(Courtesy City of Chicago, Graphics and Reproduction Center.) (*A View from Chicago's City Hall*)

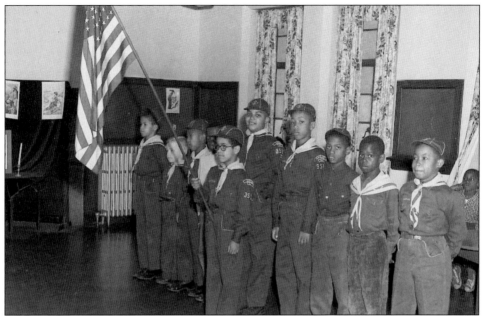

These Boy Scout troops, meeting at the First Presbyterian Church, reflect the racial makeup of the Woodlawn neighborhood in the late 1950s. After World War II, the population of Chicago's African-American community expanded and, with housing in short supply, many black families began moving to South Shore, following in the footsteps of the working-class Irish and German families before them. (*Chicago's South Shore*)

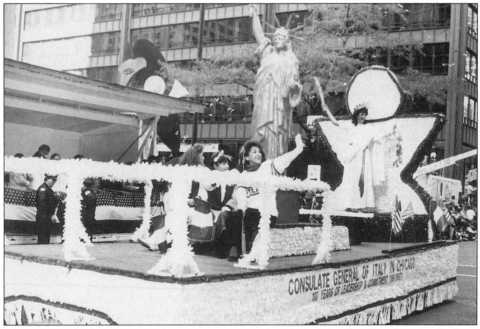

The Statue of Liberty passes Chicago's Picasso in the 1987 Columbus Day Parade. (*Italians in Chicago*)

II

City of the
Big Shoulders

Business, Industry, and
Transportation

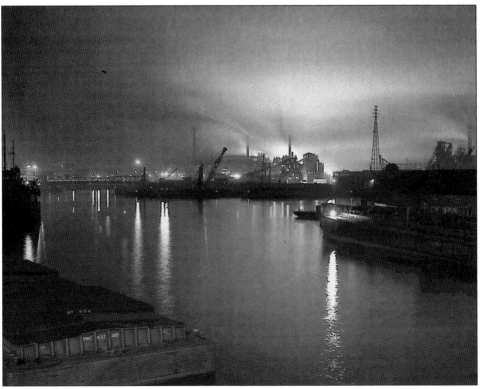

In 1959, the glow of U.S. Steel's South Works lights up the night sky, reflecting off the Calumet River. (*Chicago's South Shore*)

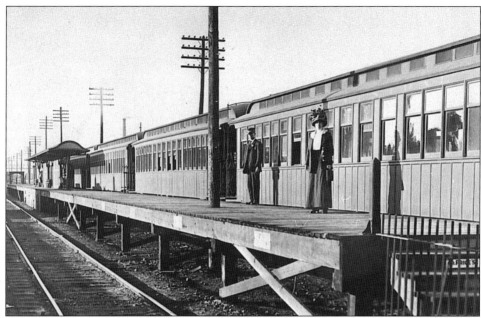

In 1882, the Illinois Central Railroad began construction of a 4.7-mile branch that extended east from the main line at 69th Street and Exchange Avenue (then named Railroad Avenue) and south to the steel mills of South Chicago. The South Chicago station opened on September 2, 1883, and is seen here in 1910. The wooden passenger cars also began serving the Bryn Mawr, Windsor Park, and Cheltenham stations, which were built about the same time as the South Chicago station. (*Chicago's South Shore*)

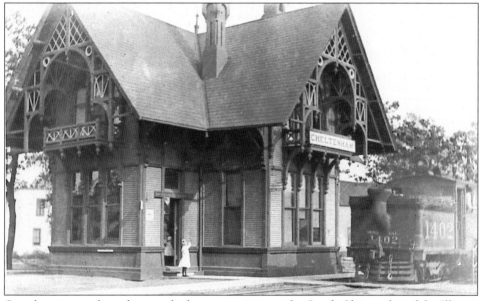

Seen here is a coal car that supplied steam engines on the South Chicago leg of the Illinois Central suburban line. The center platform is also visible in this *c.* 1900 photograph. The two-story station provided living quarters upstairs for the switchman. (*Chicago's South Shore*)

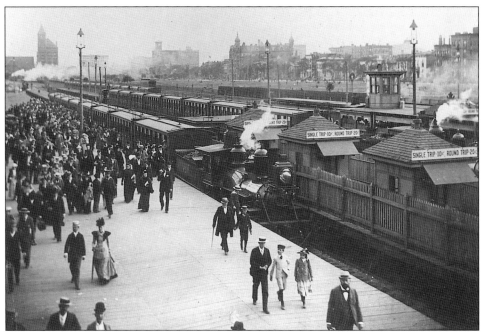

Seen here at Van Buren Street station in 1893 are the special passenger cars called "Sullivans," named after an Illinois Central Railroad executive, were built to service the World's Fair. Twelve doors down, each side loaded and unloaded passengers swiftly from the bench seats placed down the center of each car. Sullivans were designed to be converted into freight cars after the fair. (*Chicago's South Shore*)

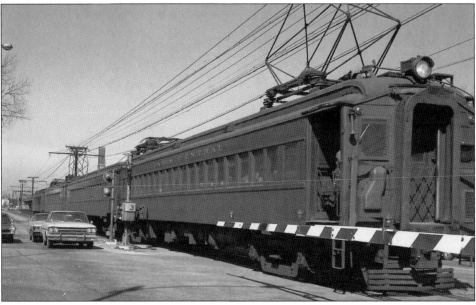

The year 1926 brought the first Illinois Central Railroad electric service to the suburban lines. Trains running on electricity, similar to the one pictured here in 1969, replaced the original steam locomotives that had been operating for 70 years. (*Chicago's South Shore*)

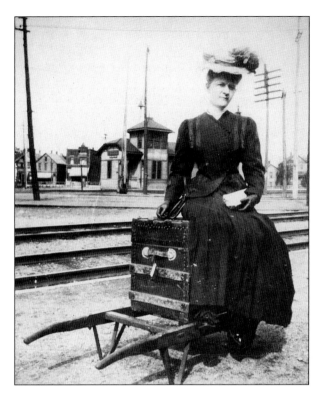

Railroads played an important role in the development of the Southeast Side. In addition to commuter trains, transcontinental trains stopped on the Southeast Side as they entered and left Chicago. This view from the early 1900s shows a young woman waiting for a train at the 100th Street Pennsylvania Railroad Station located in the East Side neighborhood at Ewing Avenue. The station and residential housing are visible in the background. Eventually, the railroad built a viaduct at this location in order to raise the tracks for both safety and traffic improvement. (*Chicago's Southeast Side*)

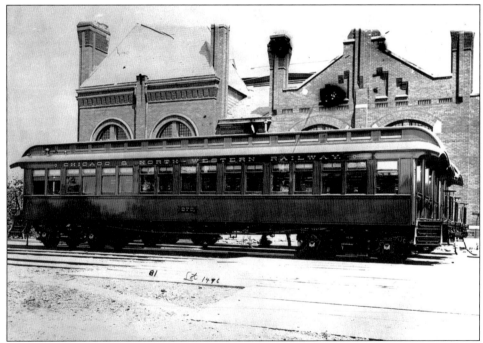

Three Pullman coaches constructed of wood are shown lined up before release to the customer, Chicago and Northwestern Railway, c. 1885. (*Chicago's Historic Pullman District*)

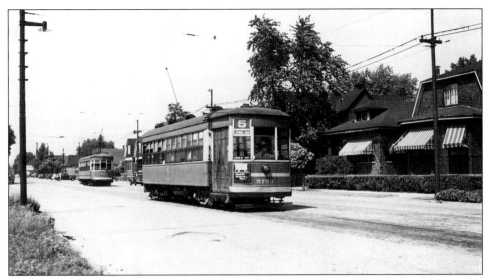

The "Number 5" street car shown here on 107th and Ewing Avenue connected the Southeast Side with central Chicago. Perhaps more importantly, it connected East Side residents with the Commercial Avenue shopping district in South Chicago. When local residents said they were going "uptown," they usually meant to Commercial Avenue. (*Chicago's Southeast Side*)

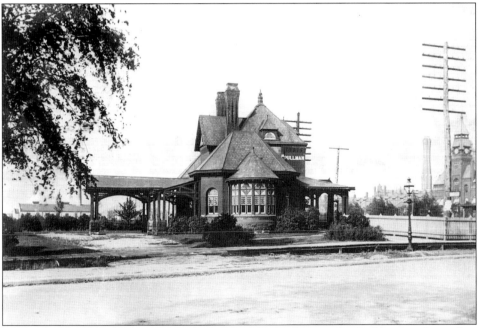

The Pullman depot is pictured here looking to the northeast. This building was located at 111th Street (Florence Boulevard) and the Illinois Central Railroad tracks. At the time that this photo was taken, the building had been moved to the west side of the tracks in order to extend Cottage Grove Avenue south. These tracks are still used to carry Amtrak and commuter passengers to and from Chicago. (*Chicago's Historic Pullman District*)

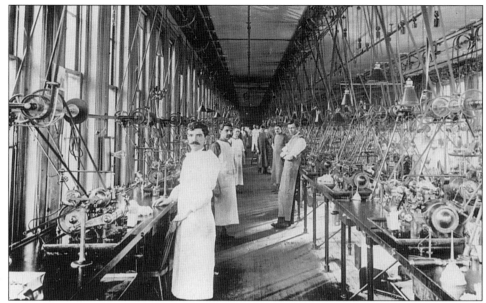

Pictured here is the screw department of the Elgin National Watch Company. More products in greater quantities were produced in the screw department than any other department in the plant. There were 250 different sizes and kinds of screws and 550 separate winding bar and spring combinations catalogued. This group of men worked in the screw room in 1899. (*Elgin*)

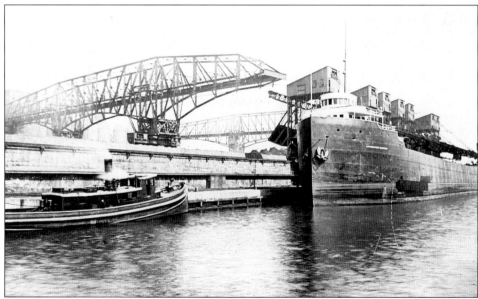

The North Chicago Rolling Mill Company chose the site for South Works because of its proximity to water transportation. Gigantic ore carriers transported iron ore, limestone, and coal to South Works. They unloaded their cargoes at slips served by huge overhead cranes. The ship pictured here is unloading its cargo at the North Slip, which connected the mill to Lake Michigan. (*Chicago's Southeast Side*)

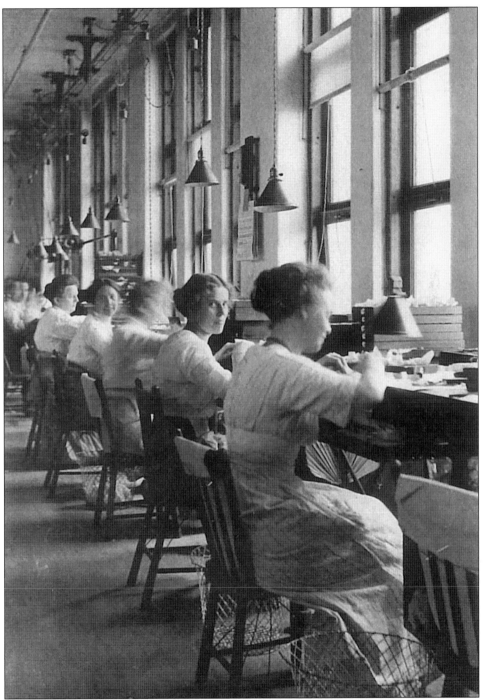

The work of these young women in the motion room of the Elgin National Watch Company was to put the plates, wheels, sleeves, and pinions (which carried the hour and minute hands) together—very delicate work! Note the lamps above them to enhance the natural light coming through the windows. (*Elgin*)

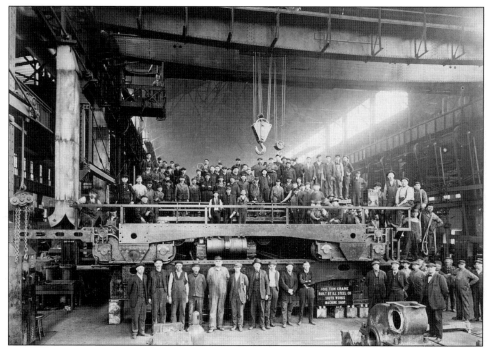

This is a 100-ton crane constructed by the Machine Shop at U.S. Steel's South Works. The machine shop made tools and parts to repair equipment used in the mill. (*Chicago's Southeast Side*)

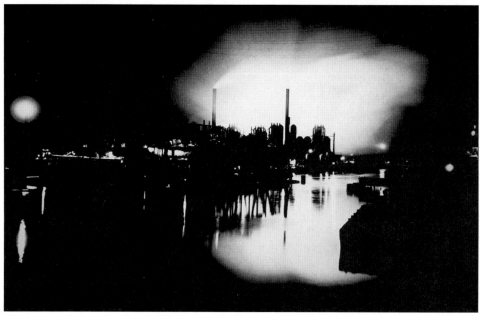

This view shows the South Works in 1947. At night the steel pouring process lit up Southeast Chicago's sky. The mills operated around the clock, seven days a week, holidays included. (*Chicago's Southeast Side*)

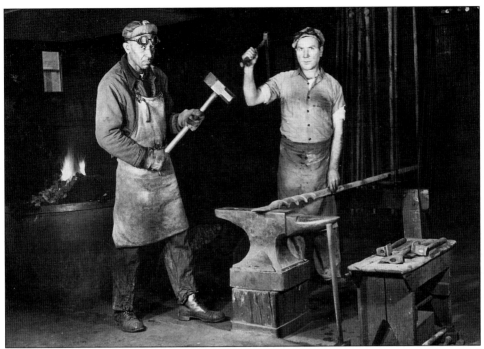

Pictured here are blacksmith Luigi Santangelo and his helper at Wisconsin Steel. Much of the labor in the steel mills was heavy manual labor. If a person had a strong back and the will to work hard they could earn a decent living in the mills. Higher education was not needed to obtain a well-paying job on the Southeast Side. (*Chicago's Southeast Side*)

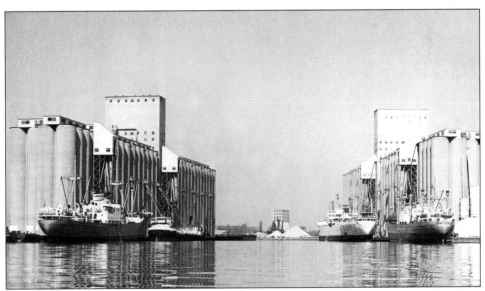

The port of Chicago is located on the Calumet River. It has the capability of handling ocean ships from its location at the western terminus of the St. Lawrence Seaway. Along the waterway, grain elevators transfer farm products to foreign and domestic ships. (*Chicago's Southeast Side*)

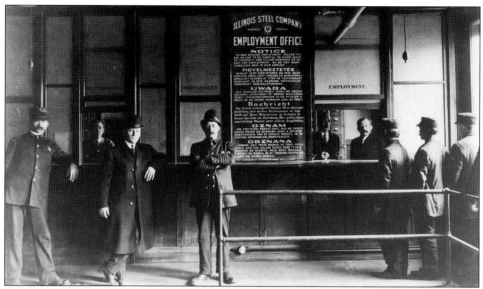

This interior view of the employment offices at Illinois Steel Company depicts job applicants and mill employees, including plant security. The multiple languages on the sign reflect the variety of non-English speaking immigrants who applied to work in the mills. The theme of the message is that the mill wants to hire workers who are safety conscious. (*Chicago's Southeast Side*)

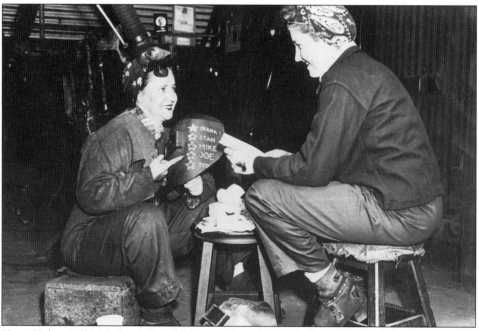

Kitty Kalwasinski Markovich and Florence Josephs worked at U.S. Steel South Works in 1945. Many women entered the steel mills during WW II to help the war effort. The names on the welder's helmet are those of her brothers serving in the armed forces. The solid star signifies that her brother Frank died in action in France. (*Chicago's Southeast Side*)

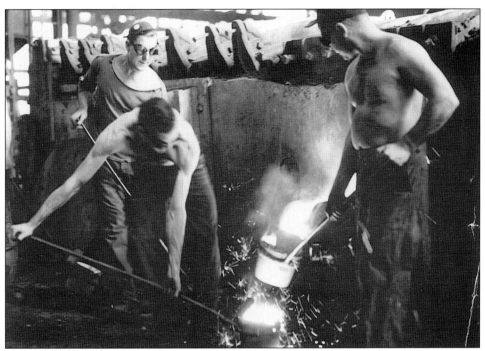

Moline Malleable Iron Company moved to St. Charles in 1893, after the Moline factory was destroyed by fire. They brought 300 men with them, including 90 molders, like those seen here. (*St. Charles*)

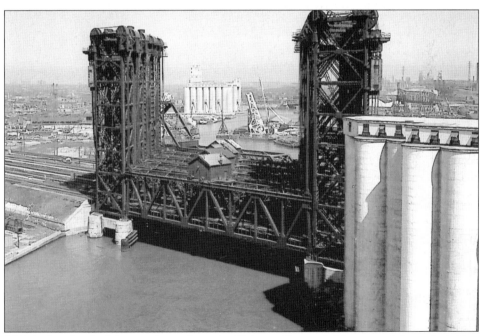

This is the view looking northeast from the Chicago Skyway bridge toward the train bridge across the Calumet River. (*Chicago's South Shore*)

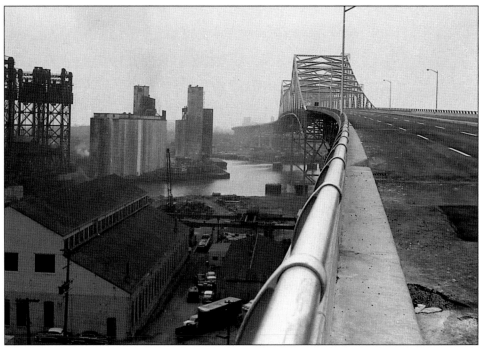

This view looks east toward the Chicago Skyway bridge over the Calumet River, one week before the tollway was officially opened in 1958. (*Chicago's South Shore*)

This view is north from the Skyway exit ramp onto Stony Island Avenue, above 79th Street and South Chicago Avenue. (*Chicago's South Shore*)

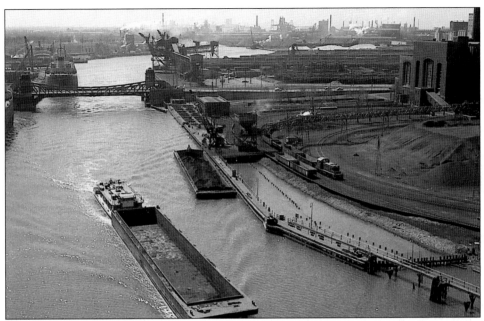

From the Skyway bridge, a coal barge on the Calumet River can be seen leaving the Commonwealth Edison station at 100th Boulevard. The Cal Sag Channel system, connecting to the Little Calumet River, brought coal up from southern Illinois through Indiana. (*Chicago's South Shore*)

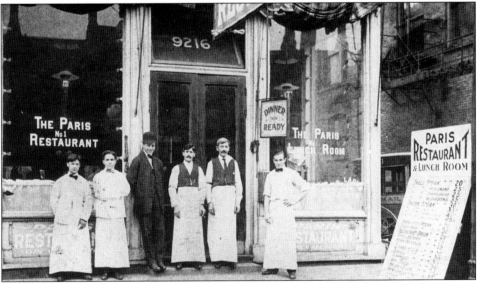

In 1916, the Paris Restaurant fed hungry steelworkers and residents from their location at 9216 South Commercial Avenue. The restaurant stayed open through the night at a time when the steel mills operated around the clock with two 12-hour shifts. The steel industry had a direct effect on community businesses and local economic conditions; whenever the mills closed or cut back on their workforce, local concerns suffered and often closed. (*Chicago's Southeast Side*)

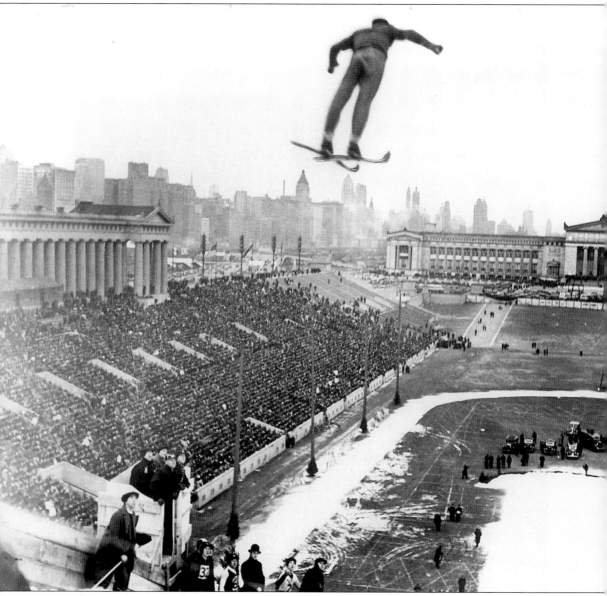

Snow was hauled to this ski jump at Soldier Field, so that demonstration (exhibition) skiing could take place. *"Build a hill, and they will come."* (*Midwest Skiing: A Glance Back*)

III

TO SERVE AND PROTECT

POLICE, FIRE, AND MILITARY

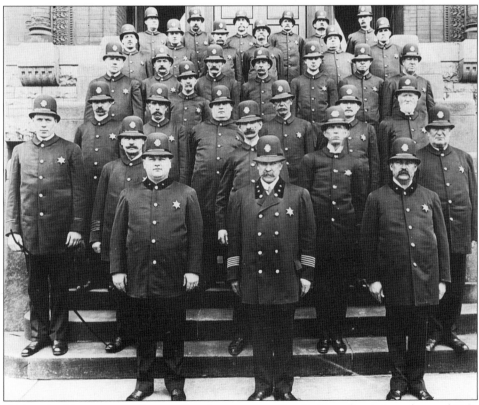

Although this appears to be a police department roll call, in reality it is a photo of U.S. Steel plant security personnel. Like a city within a city, South Works had its own security force, fire department, ambulance, and medical clinic. It also had its own power plant for electrical power. (*Chicago's Southeast Side*)

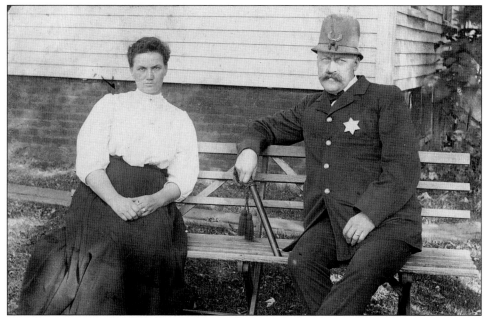

Providing police protection for Palatine had been an irregular process until Henry Law was hired in May 1896, as a full-time night watchman and lamplighter at $40 per month. He continued to serve until 1919, at which time he was receiving $80 per month. Henry Law sits here with his wife, Annie Witt Law. The photo was donated by Margaret Stroker Witt, a niece of the Laws. (*Palatine*)

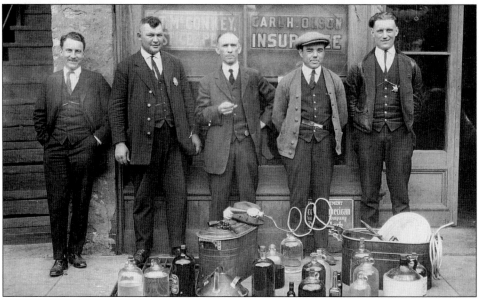

The St. Charles Police Department looks quite proud after their capture of a white lightning brew kit. This was a disaster to the local drinkers, as St. Charles was "dry" for several periods before Prohibition. The second time, in 1917, it was because the U.S. government wanted to conserve grain to feed the troops. (*St. Charles*)

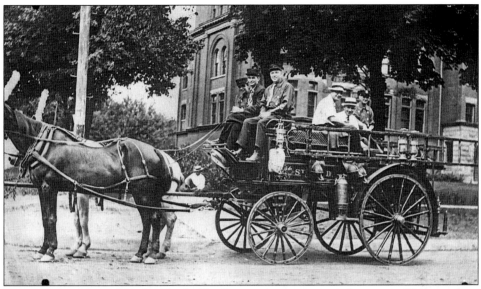

Shown are members of the St. Charles Fire Department sitting on a fire wagon. They are, from left to right: (in front seat) Fred Tyler, unidentified, and James Naughton; (on back of wagon) Fritz Modine, Roscoe Wagner, and Tom Haines. These horses are outfitted with colorful plumes, and the firemen's helmets are shown hanging on the side of the wagon. (*St. Charles*)

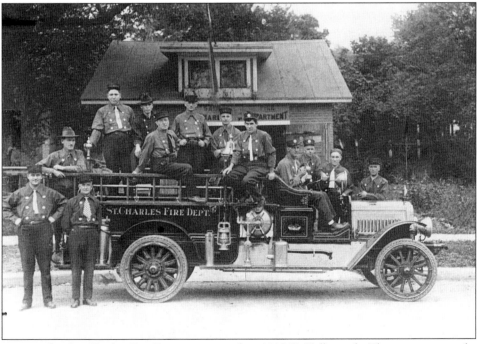

Here is the St. Charles Fire Department with a 1913 DeKalb truck. The city waterworks were completed in 1910, which made water more easily available than pumping it from the river. This used vehicle was purchased by the city in 1915. It was the first motorized vehicle for the department. (*St. Charles*)

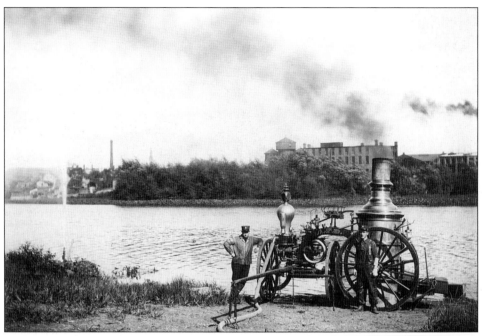

This is an early view showing Aurora's Excelsior Steamer, bought in 1875 at the west bank of the river, fighting a fire. To the left is fireman George Lowe and to the right is fireman Joseph Eye. This view was taken about 1910. (*Aurora*)

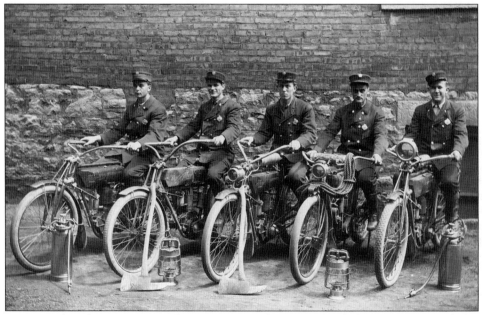

In 1914, the Thor Company of Aurora was making new-fangled motorcycles, and the Aurora Fire Department had five of them, complete with axes, lanterns, and fire extinguishers. This 1914 photograph features from left to right: "fire warriors" William Froelich, Joseph Eye, John Petersohn, Jessie Bird, and Ed Bettcher. (*Aurora*)

The St. Charles Library was one of the hundreds of Carnegie libraries. Andrew Carnegie, the steel king, donated $12,500 toward the $15,000 needed to build the St. Charles Library. The public library system began in 1906. Before that, the city had a subscription library, which required an annual $2 fee to join. (*St. Charles*)

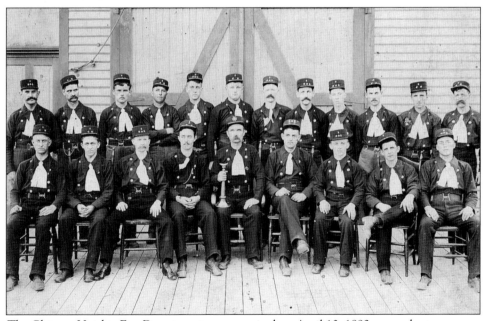

The Chicago Heights Fire Department was organized on April 10, 1892, as a volunteer group. Pictured in the center of this 1895 photograph is Chief Horace Scott, holding his brass speaking trumpet that he used to shout out orders to his men during a fire. (*Chicago Heights*)

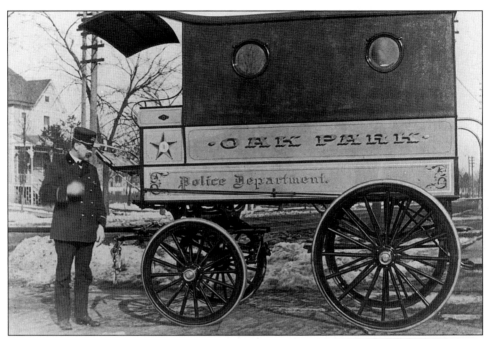

Taken in 1902, this photograph shows Oak Park's first horse-drawn police patrol wagon and ambulance, probably the one that was purchased with the $500 collected by Lt. John Schwass. By the time the Village government was established, the small force patrolled the major streets and was able to time and arrest bicycle riders who exceeded the 8 mph speed limit on their Sunday outings. (*Oak Park*)

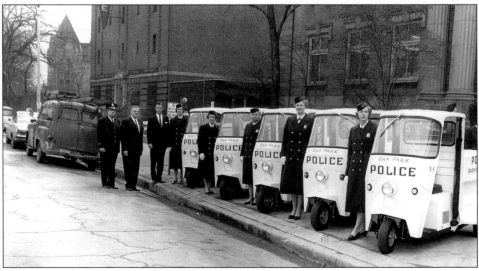

The increased role of the automobile in both the residential and business life of the community created severe and complex parking problems. Hoping to minimize the impact of illegal all-day commuter parkers who were taking public transportation downtown or those who were ignoring time limits at meters in Oak Park's business areas, the Village initiated the Meter Maid program. This photo was taken at the Municipal Building in 1966. (*Oak Park*)

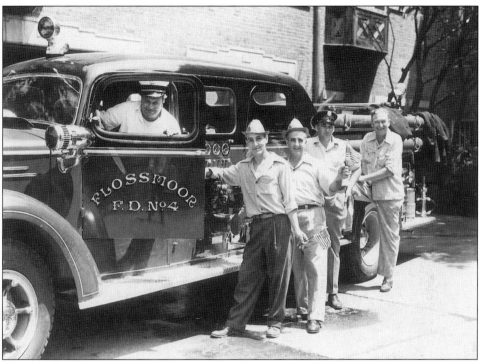

This is the Flossmoor Fire Department No. 4 Engine with five firemen, 1947-48. They were probably preparing for the Annual Fourth of July parade, sponsored by the fire department for many years. (*Flossmoor*)

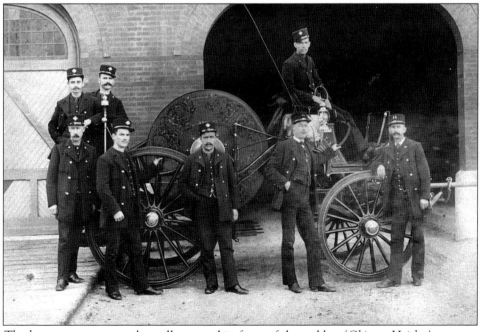

The hose cart appears to be well-manned in front of the stables. (*Chicago Heights*)

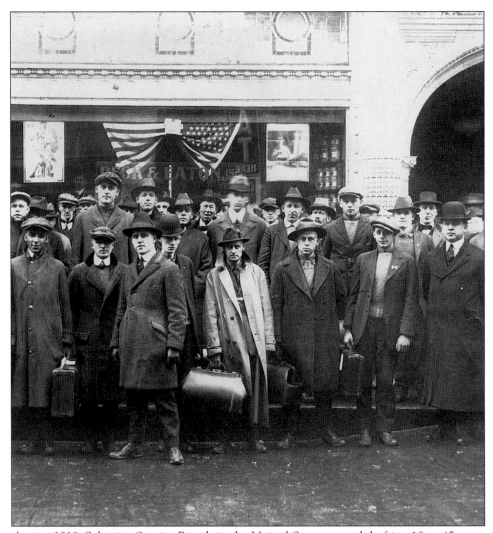

August 1918: Selective Service Boards in the United States started drafting 18 to 45-year-old men, and by the end of the war, over 24 million Americans had been registered for the draft. Of that number, 2.8 million were drafted into the army, and close to 2 million were shipped off to France, but less than that figure saw active service. Elgin had a multitude of young men ready and willing to help the Allies in the war. This non-uniformed group of young recruits seems anxious to get to France and get it all over with quickly. The distinguished-looking gentleman to the right in the front row seems to be an official of some kind, perhaps from the Selective Service Board. Posters played a big part in encouraging men to volunteer for war. The famous Joseph Leyendecker "Weapons for Liberty" poster, produced in 1918 to encourage Boy Scouts to sell bonds in the Third Liberty Loan, is in the window of the store behind the men. (*Elgin*)

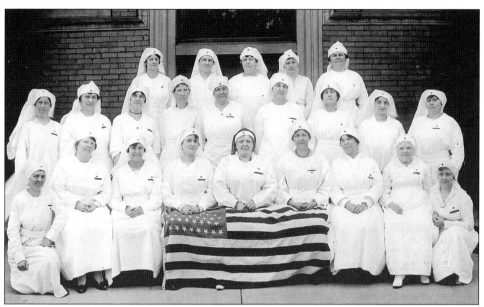

The Red Cross Woman's auxiliaries were an important part of the war effort for both World War I and II. From preparing bandages and medical supply packaging to the less formal activities of knitting warm socks and mittens, the women pictured here near the end of WW I performed many functions in support of the military. The uniforms were meant to create an identification with highly respected professional nurses. (*Oak Park*)

Public servants from the Flossmoor Fire and Police Departments pose in front of a paddy wagon that has been decorated for a community event. (*Flossmoor*)

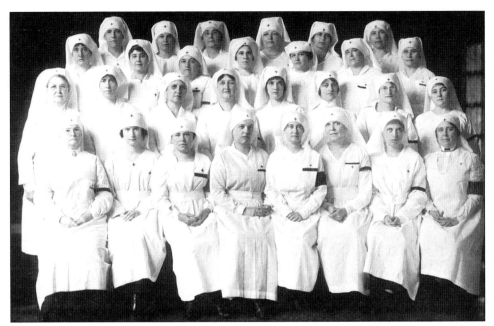

The workers on the Home Front helped give us victory in WW I. Groups such as those affiliated with the Red Cross did essential supportive war work. The Aurora Chapter of the Red Cross was organized in May 1917. These Aurorans were all Red Cross Surgical Dressing Supervisors. (*Aurora*)

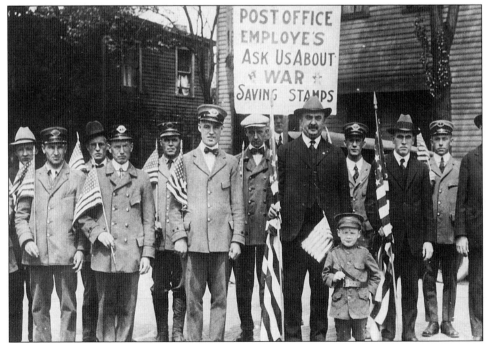

During WW I, postal employees participated in fund-raising and morale-boosting efforts on the homefront. The dark-suited man in the center is Postmaster W.H. Stolte. (*Chicago Heights*)

In 1863 General John F. Farnsworth, serving on the military affairs committee of Congress, was asked to raise yet another unit, the 17th Illinois Cavalry Regiment. Major John L. Beveridge of the Eighth Illinois Cavalry was promoted to colonel and given command of the new regiment. In the fall of 1863, recruiting and training was held at Camp Kane, and the troops were mustered into service in January and February of 1864. Camp Kane was then deactivated. (*St. Charles*)

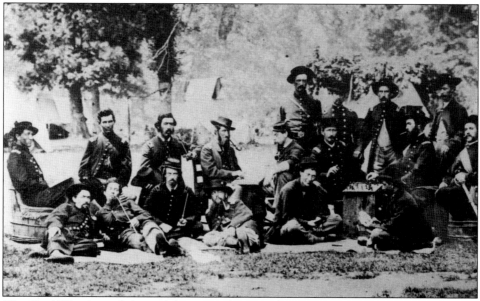

The Civil War drained Aurora's homes and surrounding areas of young men. Some sources say that ten thousand area men left for war from Aurora. This encampment photograph, c. 1864, is of the officers of the Illinois 36th. (*Aurora*)

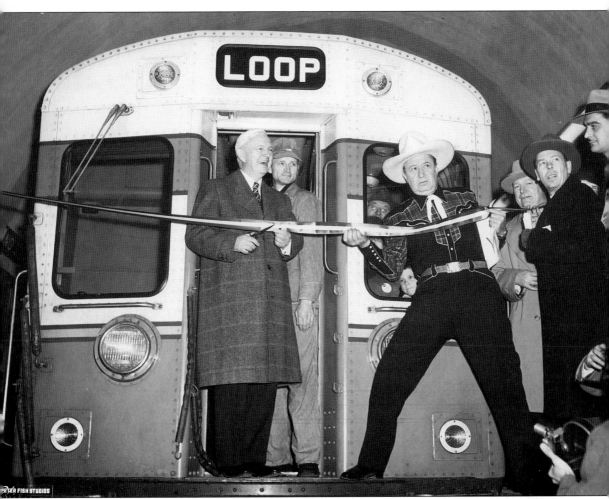

In this early 1951 view, Mayor Martin Kennelly is shown opening the Dearborn Street subway line. (Courtesy Kennelly Collection.) (*Elgin*)

IV

BEYOND THE
CITY LIMITS

CITIES AND TOWNS OF
GREATER CHICAGO

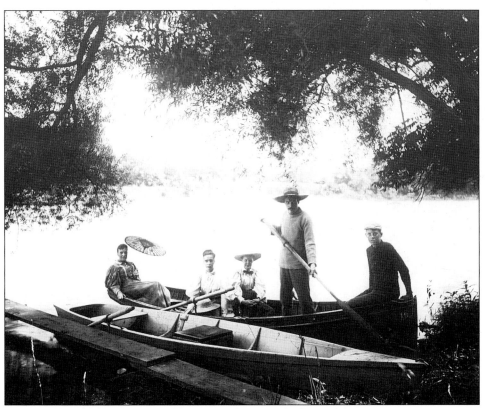

The Underwood family enjoyed being outdoors in the beautiful Fox River environment. Here, one woman keeps to the shade with her Japanese parasol as the family keeps cool on the Fox River. Underwood was a master photographer to have caught such intensity of enjoyment. (*St. Charles*)

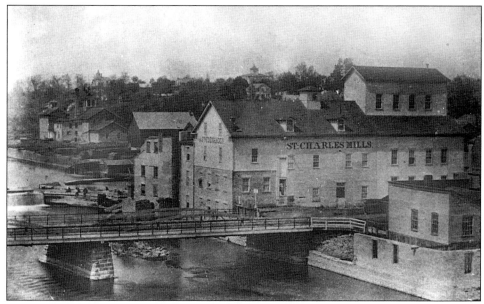

Freedenhagen Mill, shown here about 1885, was built on the site of the original sawmill built by Ira Minard and the "town proprietors." The original mill had two upright saws as well as a machine to cut shingles. Logs were delivered to the mill, and rough sawed lumber was often bartered for flour, hides, and tallow. Asa Haseltine was employed to operate the first mill. (*St. Charles*)

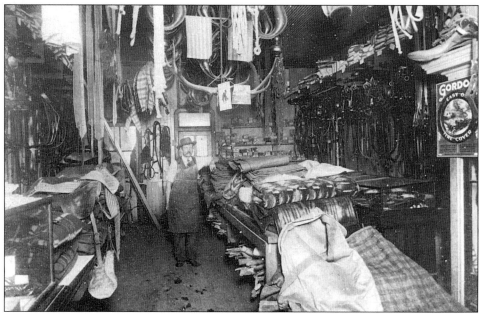

David McWilliams is proudly standing in his Harness Shop in 1877. He bought and built the shop of oak with two rooms downstairs and two rooms upstairs. In an interview for the St. Charles Heritage Center, Mae McWilliams recalled that she was born on the second floor in the Harness Shop building. (*St. Charles*)

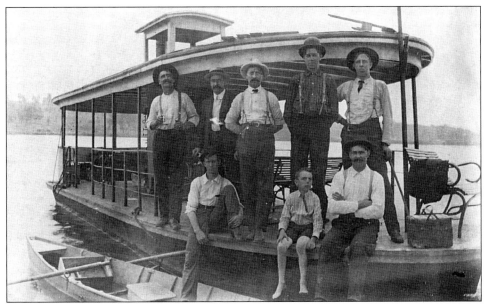

Here is a close-up view of the S.S. *Pacific* and its crew. From left to right are as follows: (standing) Charles and Victor Rockman and Jake Swanson; (seated) Oscar Johnson, Howard Collins, and John Johnson. This steamboat was driven by a coal-fired boiler. On windy days, waves would sometimes flood the deck when the boat was loaded! (*St. Charles*)

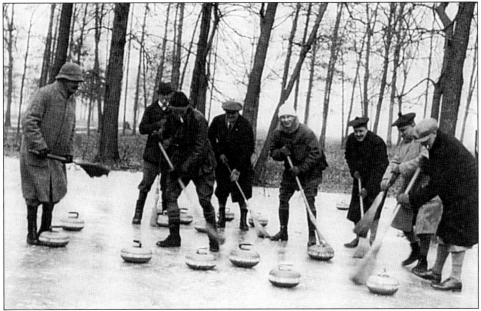

Curling was a wintertime sport enjoyed in the St. Charles area. Curling is a variant of bowling and originated in Scotland. Each man had his own curling stone, which was a large smooth stone with a handle on the top and a straw broom. The players slid these stones toward a marker on the ice using the broom to clear a path so the stone would get as close as possible to the marker. (*St. Charles*)

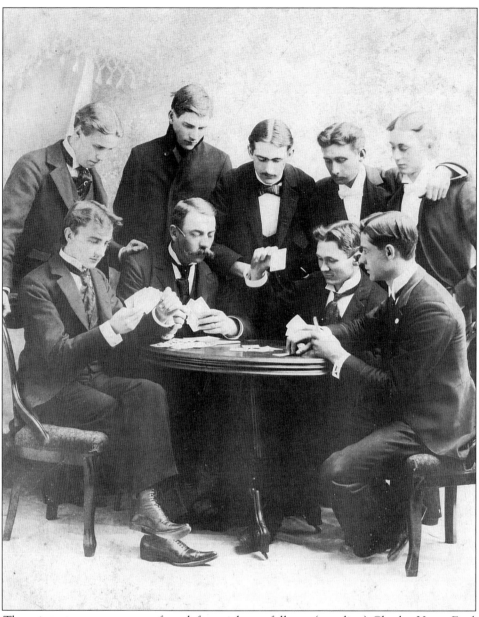

These intent young men are, from left to right, as follows: (standing) Charles Hunt, Fred Matoon, Fred Miller, Fred Pools, and Louis (Doc) Andrews; (sitting) Frank Jorney, Spencer Smith Huls, Bert Huls, and Tom Fisher. These young men posed for this photograph in 1896, dressed in their finest. From the 1910 City Directory, we find that Charles Hunt, grandson of Bela, was an attorney who also made real estate loans and sold fire insurance. Fred Miller was a dentist, while Fred Poole was a clerk at Thatcher's Grocery Store. Louis Andrews clerked at Moline Malleable Iron Company, and S.S. Huls was in business with his father as a merchant. Tom Fisher was a machinist at Crown Electric. The four at the table are probably playing whist, a predecessor to bridge. Stylish young men were usually clean shaven, and high-laced shoes were fashionable. (*St. Charles*)

In this homestead, the porch is ten steps off the ground making room for a raised basement living area. The photograph was evidently taken in the autumn. If we could digitally enlarge this image, we would see in the gentleman's right lens of his eyeglasses the reflection of the photographer and his camera. (*Aurora*)

The church school band was a marching testament to their religious faith and fervor. The repertory may have consisted of many hymns to be played in the fashion of the most famous Salvation Army Bands. This ensemble is heavy on brass with cornets, baritones, and trombones with only a sprinkling of clarinets, drums, and a lone tuba. (*Aurora*)

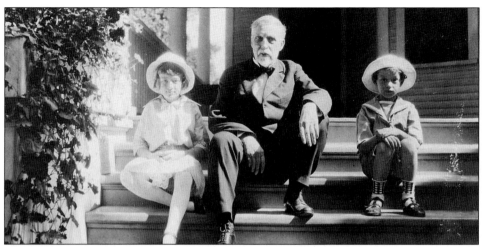

Victorian homes, for all their exterior immensity, were chopped up into many small rooms with 10- to 12-foot ceilings. Tall bay windows helped light come into the interior rooms of the house, but curtains, draperies, and a multitude of other Victorian bric-a-brac crowded out all but a pathway in some rooms, such as the parlor. Photographing people at home was best done outdoors when the photographer could capture a good image of the people. (*Aurora*)

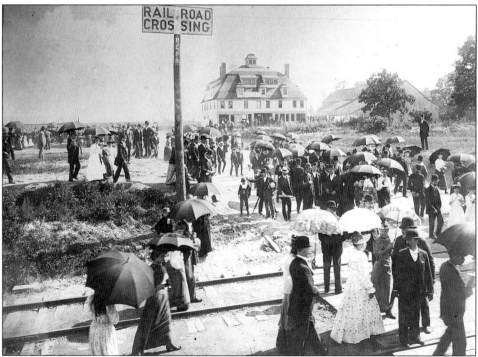

A crowd of Sunday excursionists brought out by the Chicago Heights Land Association in the early 1890s came out to see the new development. Hundreds of excursionists stayed on to take jobs in the new factories mushrooming on the east side of the city, and many purchased lots to make their homes in Chicago Heights. The building in the background is the old auditorium. (*Chicago Heights*)

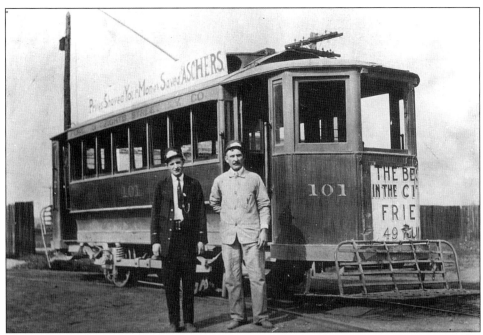

An unidentified conductor with motorman Herman Mantz (on the right) pose with the "Dinky," a train that transported people within Chicago Heights and linked up with interurbans making connections with towns like Joliet and Kankakee. Public transit between these towns was better then than it is now. In addition, advertisements were as important to businesses at that time as they are today. (*Chicago Heights*)

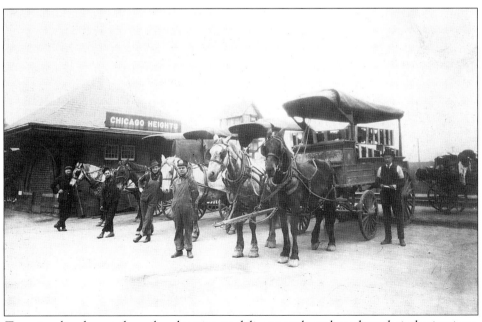

Teamsters lined up at the railroad station to deliver people and goods to their destinations. (*Chicago Heights*)

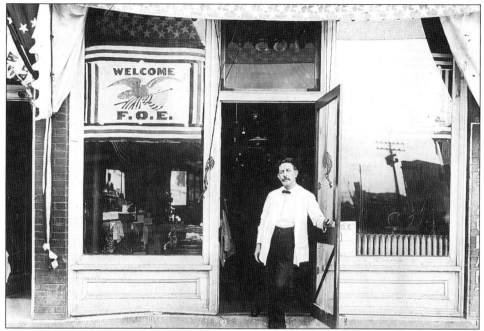

Thomas W. Booze Barbershop was located at Oak and Illinois Street in Chicago Heights c. 1902. In this photo, Mr. Booze appears to be welcoming Eagle State Convention participants to avail themselves of his services. Old Illinois Street remained a center for small shops, restaurants, clothing stores, and hardware stores until the 1970s. (*Chicago Heights*)

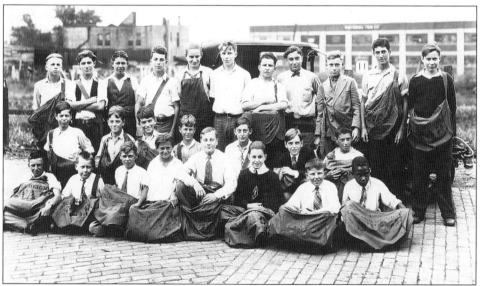

These young boys were *Star* newspaper carriers c. 1926. The best source of information about the history of Chicago Heights is the microfilm record of the *Chicago Heights Star* from 1906 until the 1960s. Published twice weekly by the Williams family, the *Star* contained detailed information on the political, economic, religious, and social lives of the city. (*Chicago Heights*)

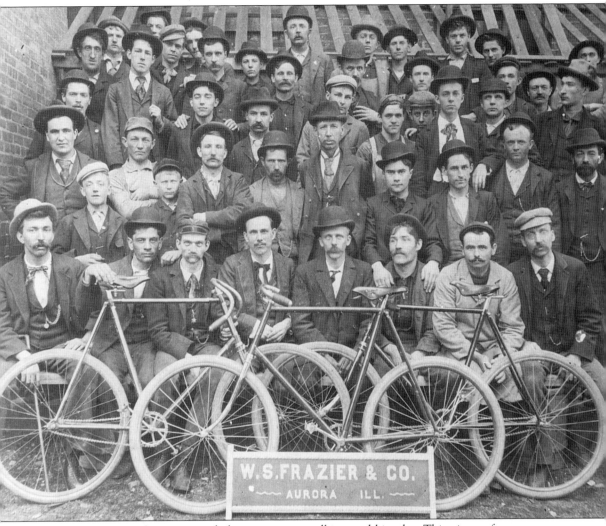

W.S. Frazier & Company made buggies, racing sulkies, and bicycles. This picture features the workers and their bicycles. Bicycles were all the rage for the well-to-do class of people in the 1890s. (*Aurora*)

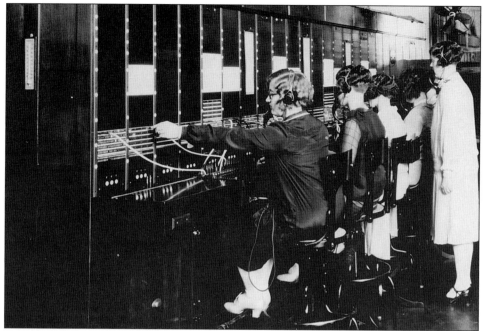

"Number please?" The telephone company in the 1600 block of Otto Boulevard in Chicago Heights provided good jobs for young ladies. Two digits, four digits, twelve-party, four-party, and two-party lines were common in the early years. The Skyline prefix and seven-number dialing came into fashion in the 1950s. (*Chicago Heights*)

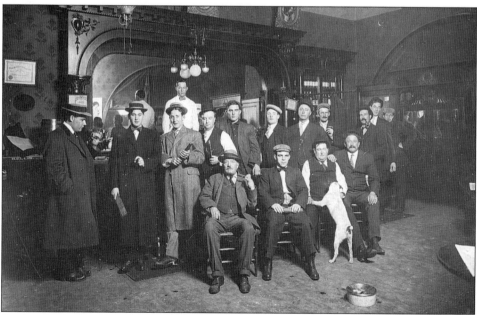

In this 1910 photo, businessmen relaxed in Chicago Heights' Victoria Hotel bar in the ambiance of sumptuous wood paneling, cigars, spittoons, and of course, Rover. (*Chicago Heights*)

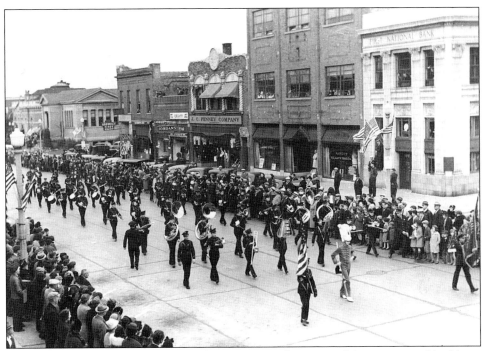

This photo documents the diverse and interesting architecture of the commercial buildings on the east side of Halsted in Chicago Heights during the 1937 Progress Parade. (*Chicago Heights*)

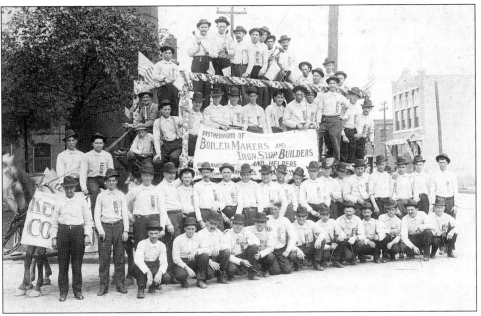

Boiler Makers union members posed for a Labor Day, 1910 photo in front of the standpipe water tower on the south lawn of Chicago Heights City Hall. Note the early streetlight. (*Chicago Heights*)

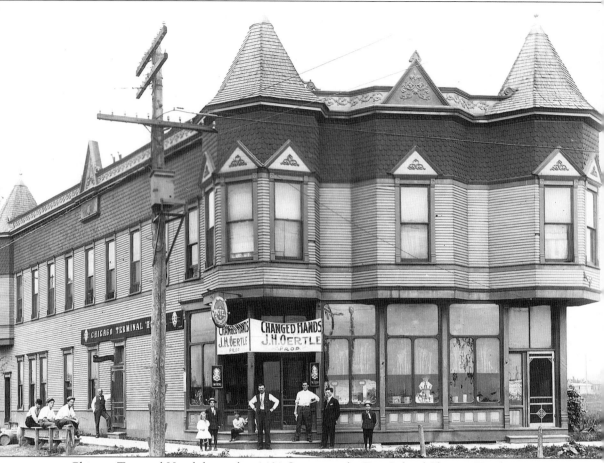

Chicago Terminal Hotel, located at 1401 Center on the East Side of Chicago Heights near the B & O roundhouse on Stewart Avenue, is pictured here in 1912. The original owner was Julius Oertle. The hotel served railroad crews, new immigrants, and workers at nearby Hamilton Piano and Morden Frog factories. (*Chicago Heights*)

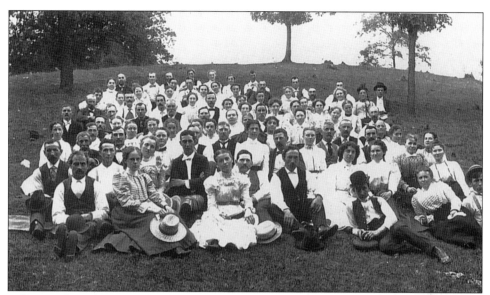

When Gail Borden's company first arrived in Elgin, it employed 30 men and 26 women. By 1891, 250 were employed and 40,000 quarts of milk were being processed daily. Writers of the day wrote of the "excessive neatness and cleanliness" of the factory. This 1899 photograph shows some of the participants in the first annual Borden's picnic, at what is now Tyler Creek Forest Preserve. (*Elgin*)

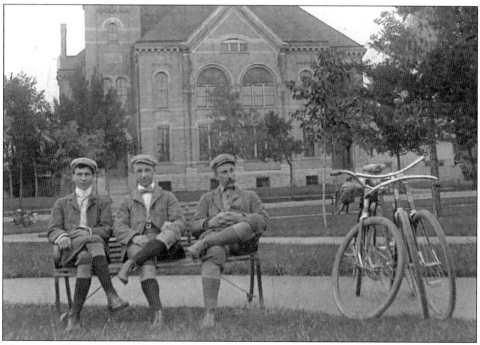

This second Elgin High School building was completed in 1884 and used until 1910, when it was razed. This was the first school in which each pupil had a desk of his own. The picture was taken from Gifford Park, sometime between 1893 and 1895. (*Elgin*)

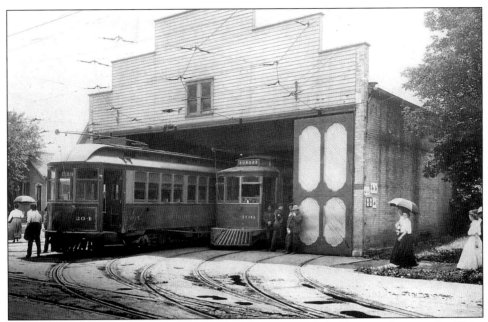

For its day, this was quite an action shot, in that it recorded passengers leaving the Elgin 204 car on the left. To the right, passengers wait to board an Aurora 106 car, on a rainy day in July 1908. Notice the complicated gridwork of electrical lines running out of the barn. (*Elgin*)

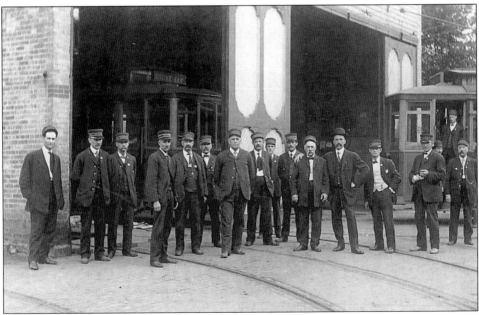

Conductors of the Elgin electric street cars pause outside the car barn in this almost 100-year-old photograph. The cars were powered by overhead electrical lines. This building had three tracks leading out to the left and a single track exiting to the right. The car in the barn is the one that serviced Grove Avenue. (*Elgin*)

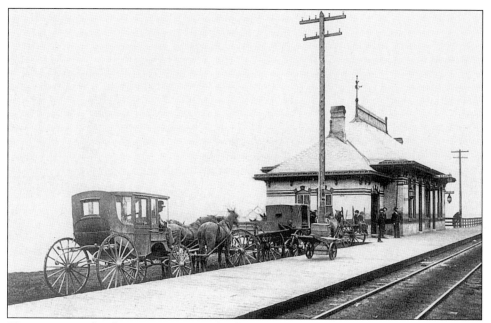

Here is a scene familiar to commuters of today. The livery stables have sent their "cabbies" out to meet the train. Two young train spotters are sitting on the side of a cart waiting for the train to appear. This moment in time was recorded at the Chicago, Milwaukee & St. Paul railroad station in Elgin. (*Elgin*)

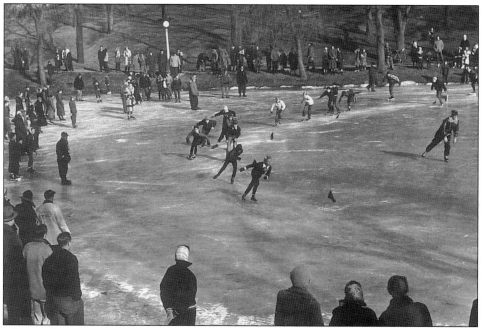

The Lords Park upper lagoon gave ice skaters a real chance to show their stuff. Here is a group of young skaters involved in a race around a flagged course. The abundance of parks in Elgin added to the quality of life for the residents of the city all year long. (*Elgin*)

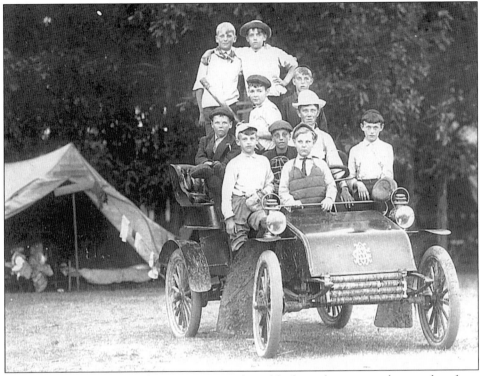

Even better than building dream cars, young boys liked to pile into a real car and go for a spin once they finished a tough ball game at Camp Elgin. This nine-man squad is proudly sporting their gloves, bat, and catcher's chest protector. The tent shown in the background is large enough to sleep this entire team from 1906. (*Elgin*)

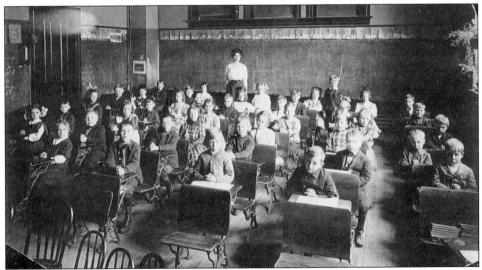

With serious expressions and folded hands, a first grade class at the Cossitt School in La Grange posed for this photograph around 1910. High ceilings helped keep classrooms cool during warm weather. Neither the teacher nor any of the students is identified. (*La Grange*)

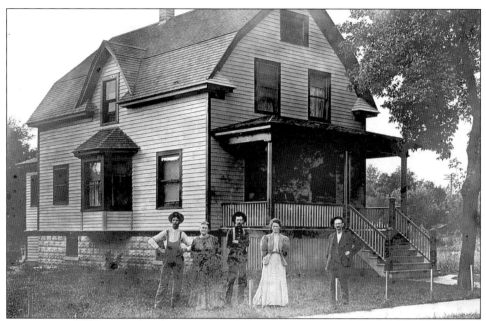

Florence Robb Taroli contributed this photograph of her pioneering La Grange family. She identified them, from left to right, as her Uncle Al, Grandmother Violette Rutan, Uncle Fred, Aunt Jen, and Grandfather Rutan. Here the family is assembled in front of their house on Stone Avenue. (*La Grange*)

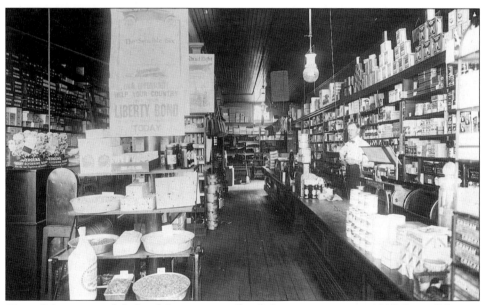

Harry Schoppe stands behind the counter of his Palatine area store in 1917. Louis Schoppe died in 1944. It was about then that Schoppe's stopped selling groceries. Old-timers used to gather around the pot-bellied stove for conversation and storytelling. The wooden building burned down while occupied by 26 North Mod Shop and was replaced by a modern brick building that now houses a card shop. (*Palatine*)

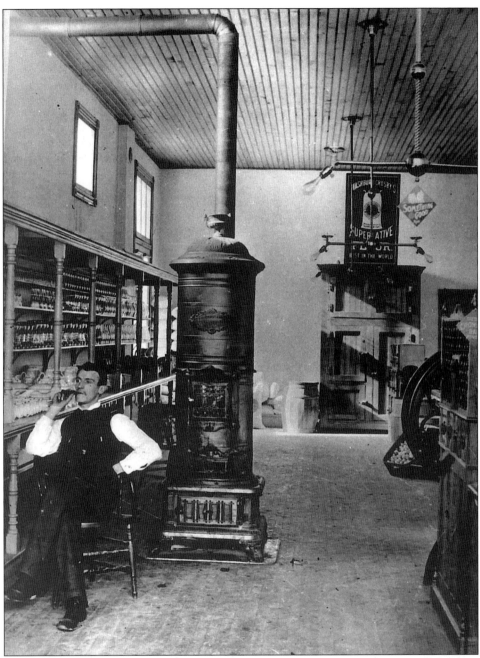

August Scheele sits proudly in his Elgin grocery store in this photograph taken in 1900. He and others emigrated from that part of Germany that was once the kingdom of Hanover before 1871. He began his grocer career by clerking in a general store but opened his own store in 1899. Scheele made it a point to be the one who opened the store each day, always looking at the store from the viewpoint of the customer. As you can see from the window placement, this first store was in a basement, but a new store building was completed in 1902 and expanded in 1910. (*Elgin*)

A 1966 reception honors the Adrian Dominican Sisters at Infant Jesus of Prague Catholic School in Flossmoor. (*Flossmoor*)

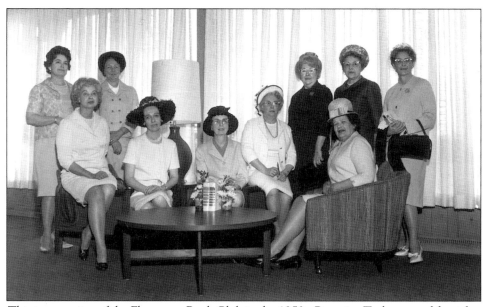

This is a meeting of the Flossmoor Book Club in the 1950s. Berneice Taylor, seated far right, is shown as the new president. (*Flossmoor*)

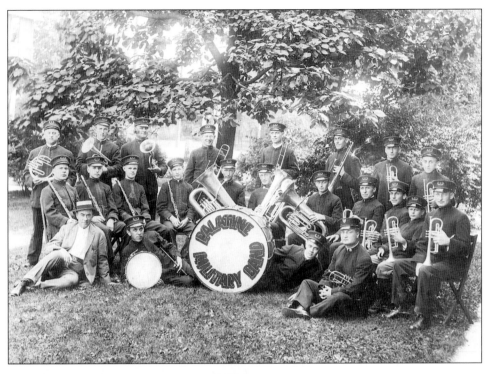

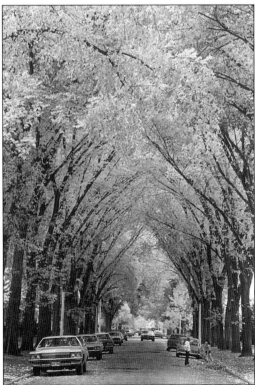

The Palatine Military Band was organized by J.H. Schierding in the 1870s and continued to operate until 1935. The band always led the Memorial Day Parade and gave weekly concerts in the bandstand until 1921. Early on the Fourth of July morning, the band toured the town on a haywagon, playing stirring music. This photo was probably taken around the turn of the century. (*Palatine*)

By the time Oak Park reached its maximum population around World War II, the elm trees that replaced the earlier oaks had developed stunning canopies on the north/south residential streets as seen in this 1979 photo of the 1100 block of South Wenonah. Dutch Elm Disease took hold and many trees were lost in the 1960s and early 1970s. A massive containment and restoration program was started, but the destruction continues. (*Oak Park*)

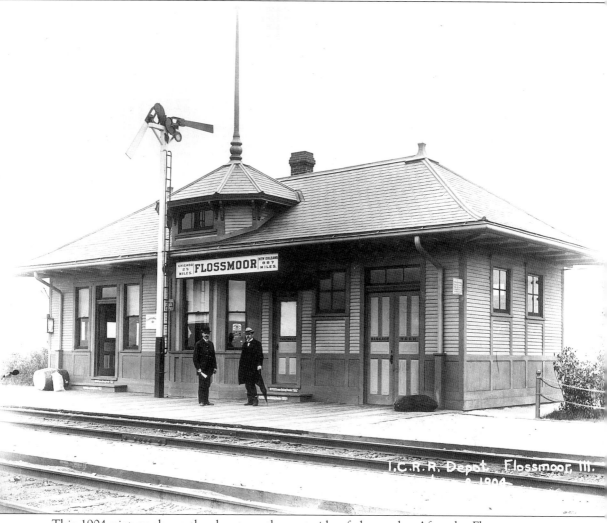

This 1904 picture shows the depot on the east side of the tracks. After the Flossmoor Country Club opened, and before the station had been fully converted to a passenger facility on the west side of the tracks, the railroad would lay planks across the rails for people exiting the train. (*Flossmoor*)

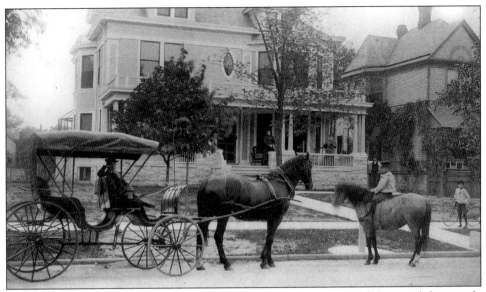

When this Oak Park photograph was taken in 1896, the horse was still king and those with the means to own one usually kept it in the small stables behind their large Victorian homes. Servants' quarters were in coach houses above the barns of the wealthy while feed was kept in the loft above the stable. The doors over some contemporary garages reveal the structure's early history as a barn. (*Oak Park*)

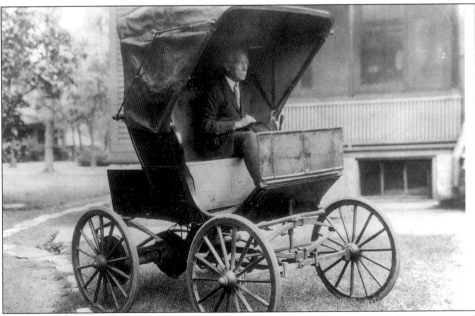

In the early days of the automobile, there were many competing small manufacturers in and around Illinois. It was by no means certain that one form of internal combustion engine would wipe out all the competitors. Charles E. Roberts, a local inventor and engineer and later a friend and supporter of Frank Lloyd Wright, sits in an electric car that he owned in 1897. This photograph was taken in Oak Park. (*Oak Park*)

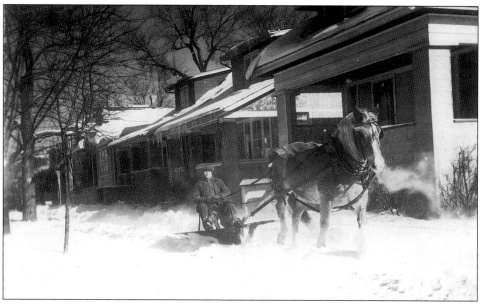

Although the automobile had won the day long before this photo was taken in the winter of 1943-44, there were still horses in Oak Park. This man uses a plow to clear sidewalks on the 1000 block of South Lyman Avenue. The Village's trucks were not able to plow the sidewalks and small motorized equipment had not yet become a viable alternative for the average homeowner. (*Oak Park*)

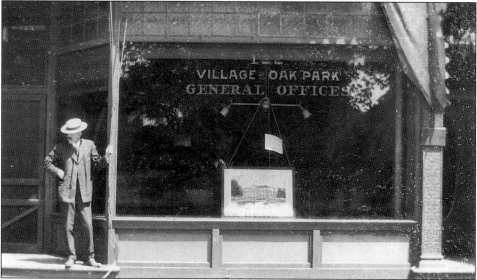

The Village of Oak Park General Office was first housed in a storefront at 122 North Oak Park Avenue when the community broke away from the Cicero Township. This 1902 photo was taken during the construction of the municipal building one block east, a move opposed by those citizens who wanted the building closer to the population center of the Village. Fire and police services were at other locations, and Board meetings were held at Scoville Institute. (*Oak Park*)

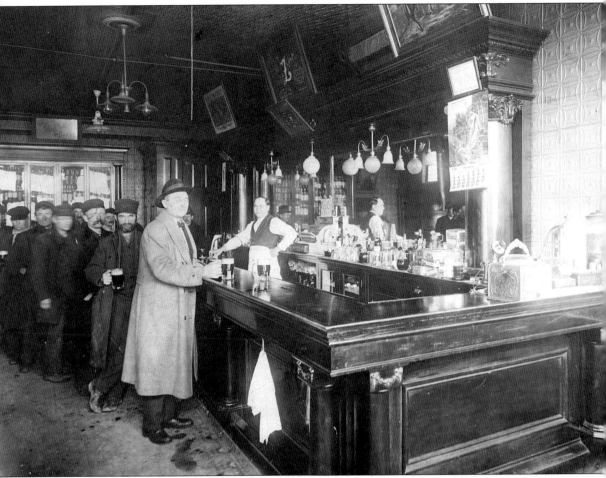

Art Richert tended bar in his tavern located at the northeast corner of Main and Halsted in Chicago Heights in 1919. (*Chicago Heights*)

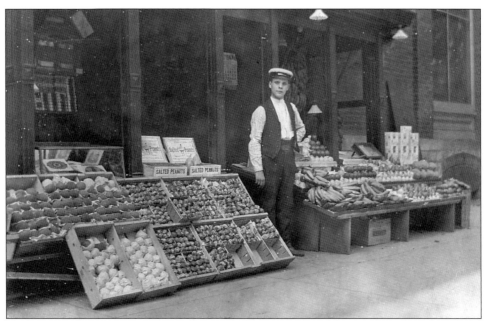

The daily purchase of fresh produce was very important to Oak Park residents. Middle class housewives considered it desirable to shop for the fruit, vegetables and meat for that day's dinner, if at all possible. Here, the brother-in-law of Gus Cutsuvitis stands in front of the family owned fruit stand in 1902. The fruit stand was a fixture on the West side of Marion at Lake starting in 1896. (*Oak Park*)

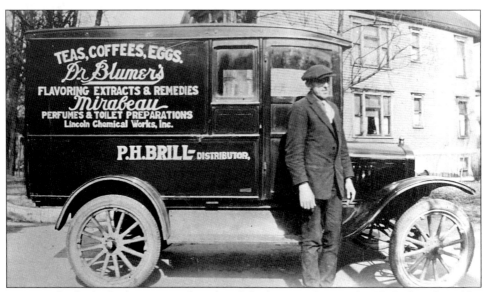

Motorized vehicles had pretty much replaced the horse and wagon by 1918 when firms like P.H. Brill were making the rounds through Oak Park, servicing the several small businesses that stocked the various products they distributed. Note the range of products, from staples like coffee and eggs to toiletries and various herbal and patent remedies for whatever might ail the public. Trucks were small and deliveries were daily or weekly. (*Oak Park*)

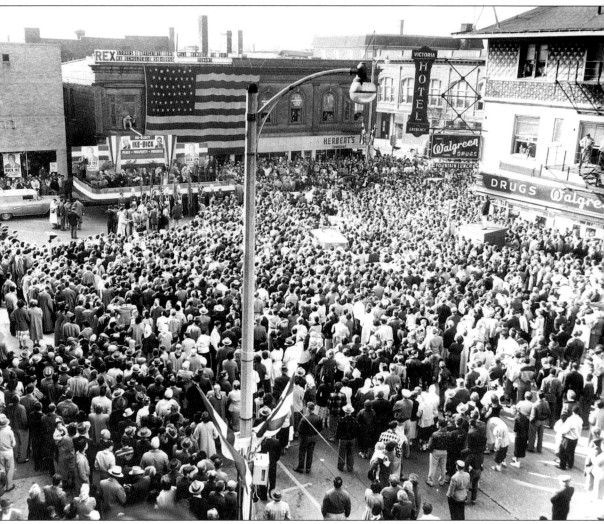

This is a scene from the podium on that special day in 1956 when Richard Nixon and Governor Stratton brought the presidential campaign to downtown Chicago Heights. (*Chicago Heights*)

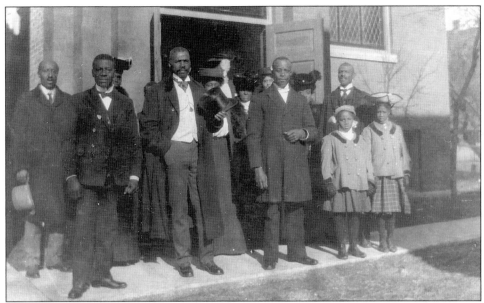

Members of Mt. Carmel pose outside the church on a Sunday morning soon after its founding. The Church served both the families of independent entrepreneurs and the larger number of people engaged in hotel, domestic, and transportation work. As the commercial area of downtown grew after the opening of Marshall Fields in 1929, housing was replaced by businesses and the small black community was effectively dispersed. (*Oak Park*)

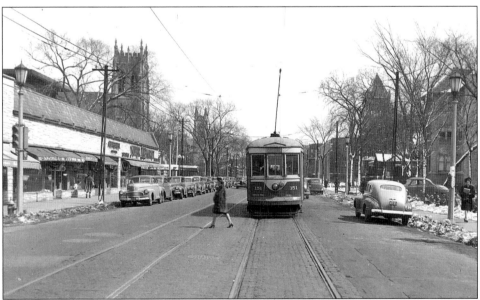

Automobiles were everywhere by the time this picture was taken in March 1947, yet the electric trolley still held sway on most of the main arteries of the Oak Park. The newspapers of the day commented on the scarcity of parking. This shot of Lake Street shows tightly packed cars on the North side of the street lined with retail stores. (Photo courtesy of Downtown Oak Park.) (*Oak Park*)

Oak Park's liberal Unitarians and Universalists built their church on Wisconsin in 1872 when the old Unity group became Congregationalist. When their building burned in 1905, Frank Lloyd Wright was asked to build a new structure in the heart of the Village opposite First Congregational, creating his world renowned masterpiece. It was dedicated in 1909 and has since absorbed several other congregations. (*Oak Park*)

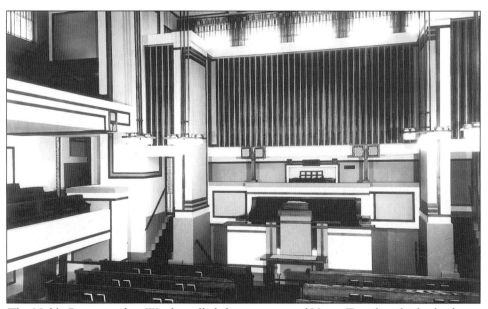

The Noble Room is what Wright called the sanctuary of Unity Temple, which also has a smaller cube shaped structure that serves as the social hall. A National Historic Landmark and a daring reinterpretation of the old New England Congregational church type, the congregation recognized its importance by supporting a separate restoration organization and granting the first protective interior and exterior easement of a church in the United States. (*Oak Park*)

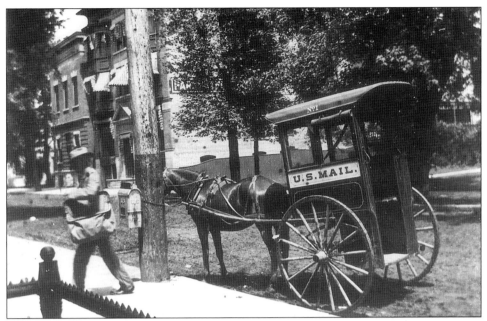

This undated photograph illustrates mail delivery in Oak Park near the turn of the twentieth century, with one Captain A.A. Busett driving Horse and Buggy #1 on his rounds. The mailbox on the pole dates back to the early 1890s when it was deemed impracticable for people to bring mail to the Post Office from around a community that was rapidly expanding to the east, north, and south. (*Oak Park*)

Ironwork fencing began to replace common wood fencing by the turn of the century. Originally, fencing in a frontier town was to keep one's animals from wandering away or to prevent other animals from wandering onto your land. This is the David C. Cook home at Gifford and Division in Elgin, which later served as the Bowes Nursing Home. (*Elgin*)

As part of the same challenges to the status quo that prompted Vatican II, the Civil Rights Movement, and various protests and marches, the Peace Movement certainly had its advocates in Oak Park. Pictured here are two anti-war leaders: Lenin Pellegrino, a local physician and civil rights activist, and Father Edward McKenna, one of the clergy who spoke out in support of this cause. (*Oak Park*)

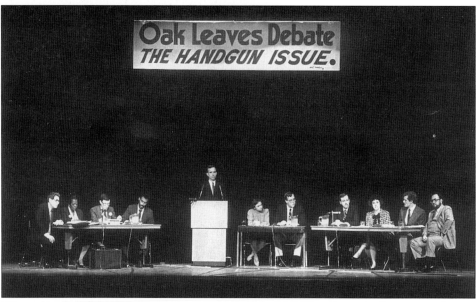

The ownership and sale of handguns in Oak Park had been an increasingly emotional issue through the first half of the 1980s. The Village Board finally forbade both the sale with firearms and ownership of handguns except under very narrow conditions. Victims of gun violence, lawyers, civil libertarians, and the police all took sides. Pictured is a 1985 debate before a non-binding referendum that eventually sustained the Board position. (*Oak Park*)

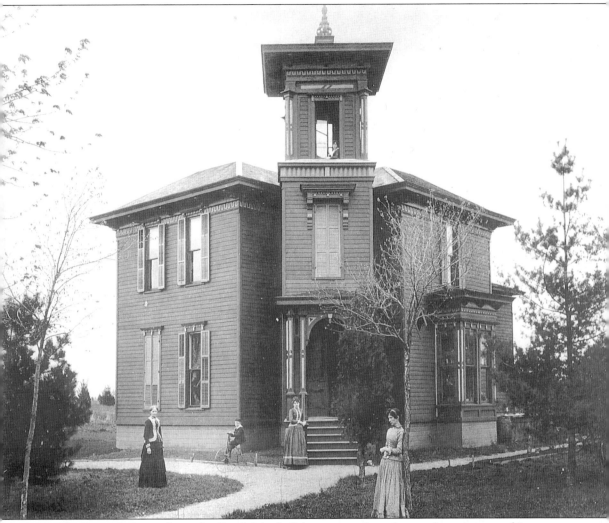

The Dietrich home, later the Frank Mitchell home, stood on the northeast corner of La Grange Road and Cossitt Avenue in La Grange. This photograph was taken in 1890 and shows the house's Italianate influences, which include projecting cornices, tall, thin windows with working shutters, and an entrance tower topped with a cupola. (*La Grange*)

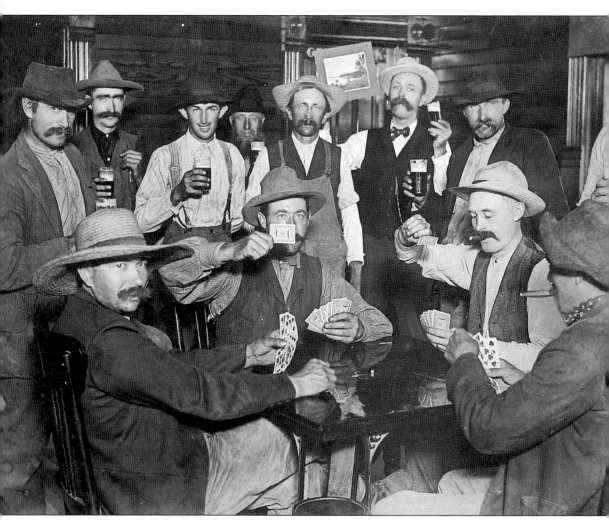

This group, inside the Kunze Saloon (southeast corner of Brockway and Slade Streets in Palatine) in the early 1900s, seem to be having a grand time. They are, from left to right, as follows: (seated) William Henning, Fred Henning, Henry Hitzeman, and Charles Streus; (standing) Charles Henning, Henry Bruhns, Fred ?, Grandpa Meyer, Henry Roesner Sr., Al Smith, Fred Gieske, and August Hackbarth. (*Palatine*)

V

THE WINDY CITY

POLITICS

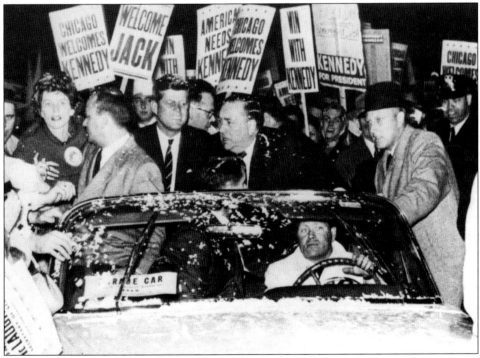

Five days before the 1960 presidential election, Chicago Mayor Richard J. Daley orchestrated the largest torchlight political parade in the city's history for Sen. John F. Kennedy. As chairman of the Cook County Democratic organization, Mayor Daley went all out, organizing a large number of his party workers as well as average citizens who lined Madison Street for the Democratic presidential candidate. (Courtesy Kennedy for President Campaign.) (*A View from Chicago's City Hall*)

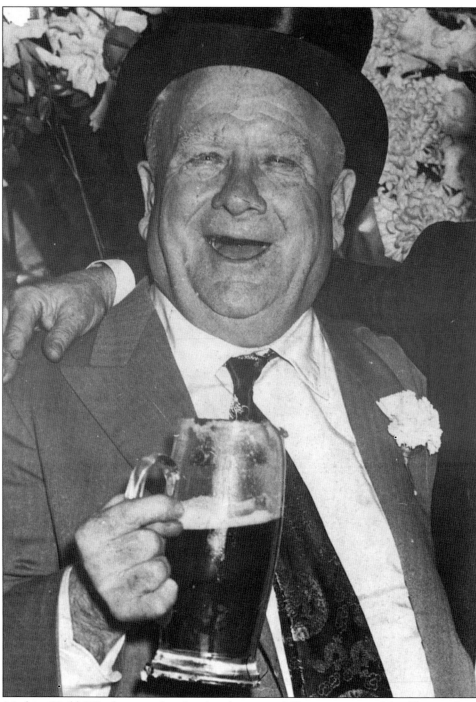

Mathias "Paddy" Bauler, a north-side saloonkeeper and 30-year veteran of the Chicago City Council, appears here with his beery smile and silk top hat. Bauler was famous for his 1955 quote, "Chicago ain't ready for reform yet." (Courtesy Holime Collection.) (*A View from Chicago's City Hall*)

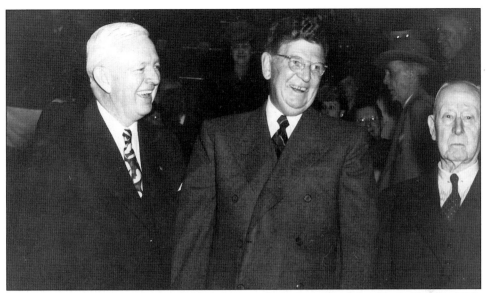

Three former Chicago mayors, who led the city through much of the first half of the 20th century as well as a part of the 19th century, are pictured here, along with the dates of their terms in office. They are, from left to right, as follows: Martin Kennelly (1947–1955), Ed Kelly (1933–1947), and Carter H. Harrison II (1897–1905 and 1911–1915). (Courtesy M. Kennelly Papers.) (*A View from Chicago's City Hall*)

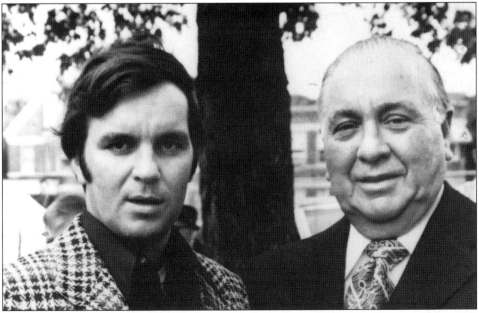

The son, who has served in office since 1989, and the father, who served from 1955 to 1976, have together led Chicago for three of the five decades since 1950. Alike in many ways and different in others, both men have shared one overriding belief: Chicago is not only their kind of town, it's also the greatest city in the world. (Courtesy City of Chicago, Press Secretary's Office.) (*A View from Chicago's City Hall*)

Italian Consul General and Chicago Heights Mayor Thomas address an outdoor group of Italian Americans in the 1920s. (Italian-American Collection.) (*Italians in Chicago*)

First Lady Pat Nixon and Mayor Richard J. Daley lead the Columbus Day Parade down State Street in the early 1970s. Pictured in the front lines are, from left to right, Gov. Dan Walker, Aldermen Vito Marzullo and Fred Roti, businessman Anthony Paterno, County Commissioner Frank Chesrow, and Parade Chair John Porcelli. (*Italians in Chicago*)

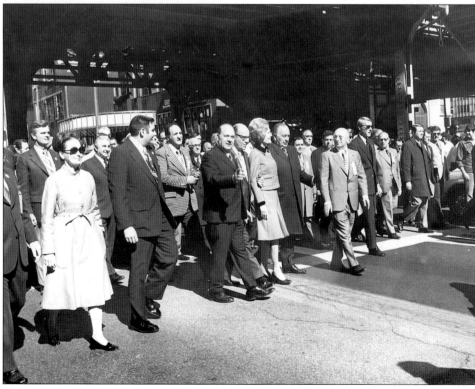

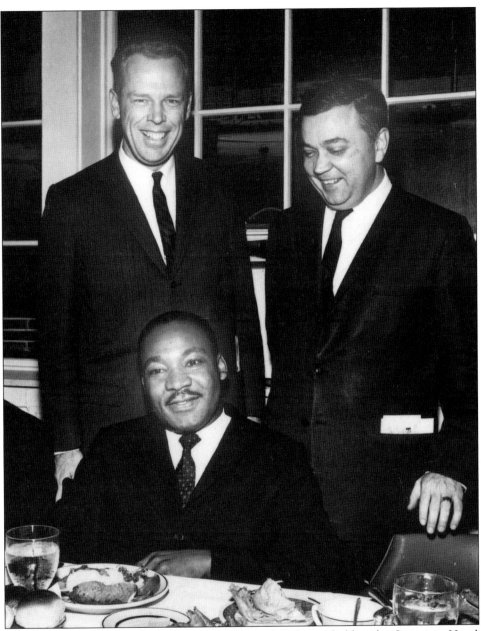

Pictured here is Rev. Martin Luther King Jr. at a 1962 dinner held at the Orrington Hotel in suburban Evanston, Illinois. Looking on is Ed Marciniak, director of Chicago Commission on Human Relations (right) and an unidentified man. (Courtesy Ed Marciniak Collection.) (*A View from Chicago's City Hall*)

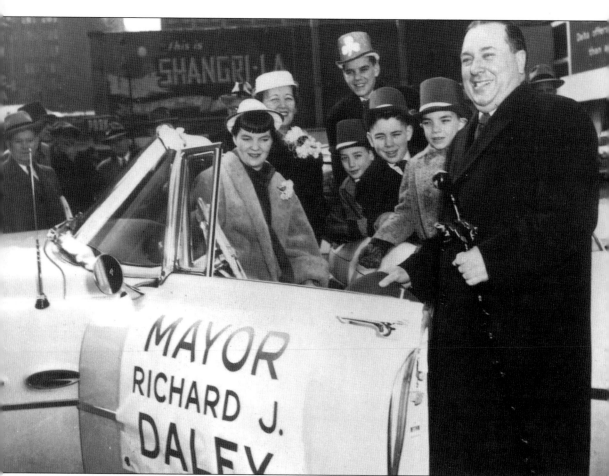

In 1956, Mayor Richard J. Daley decided to walk instead of ride in his first St. Patrick's Day parade. About to send him off with his walking stick are his wife and family, including a future Chicago mayor, young Richard M. He is seen in the background wearing the tall hat with the shamrock. (Courtesy Urban Historical Collection.) (*A View from Chicago's City Hall*)

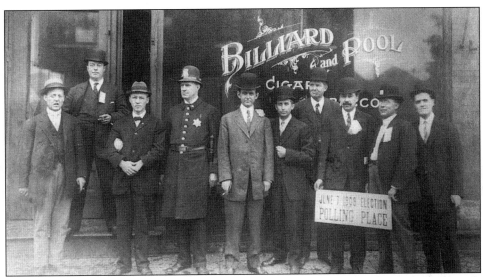

Politics in South Shore have largely reflected the traditions of the city. Although dominated by the Democratic Party, a Republican organization was successful in maintaining a strong presence in the neighborhood. Identified in a photograph from election day, June 7, 1909, are, from left to right: Mr. Springer, unidentified, unidentified, Mr. McNamara, Mr. Hoaberg, unidentified I.C. ticket agent, Charles McLaughlin, Andy Gaughn, Augie Wallers, and Gilbert W. Morgan. In addition to a polling place and pool hall, the upper floor of this building was the site of the original Bradwell School in the late 1800s. (*Chicago's South Shore*)

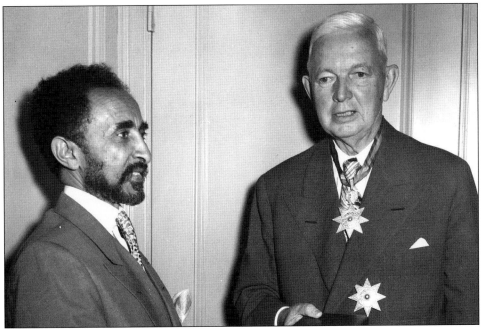

In the summer of 1954, Mayor Kennelly welcomed Ethiopian Emperor Haile Selassie to Chicago. (Courtesy Kennelly Collection.) (*A View from Chicago's City Hall*)

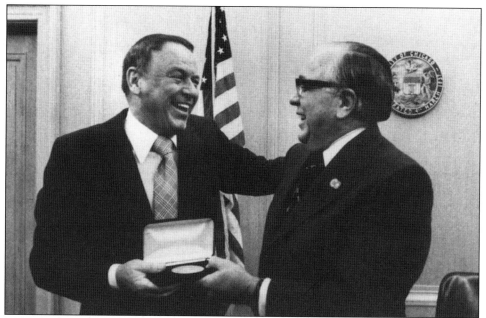

"Old Blue Eyes," Frank Sinatra receives a key to the city from Mayor Daley. The mayor was a big fan of Sinatra's vocal version of the song *Chicago—My Kind of Town*. (Courtesy Office of the Mayor's Press Secretary.) (*A View from Chicago's City Hall*)

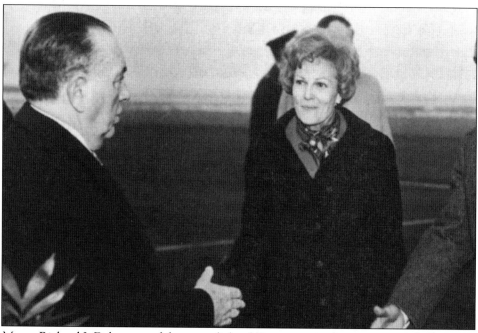

Mayor Richard J. Daley, one of the most diehard Democrats in the country, cordially greets Republican President and Mrs. Richard Nixon at O'Hare Airport. Daley had true reverence for the office of President, and it was also good politics for his city. (Courtesy Urban Historical Collection, Rakove File.) (*A View from Chicago's City Hall*)

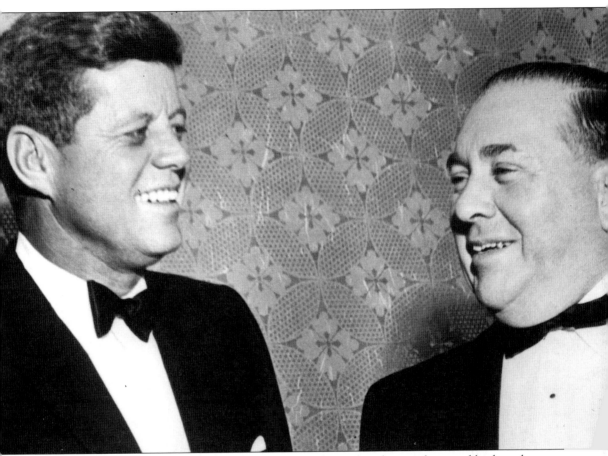

The Daleys and the Kennedys have had a close relationship that can be traced back to the 1950s, when Joseph P. Kennedy Sr. and Richard J. Daley became political allies. The elder Kennedy had become a Chicago player when he purchased the Merchandise Mart—a huge office and commercial structure—in 1946. This picture shows Pres. John Kennedy and the mayor truly enjoying each other's company. (Courtesy City of Chicago.) (*A View from Chicago's City Hall*)

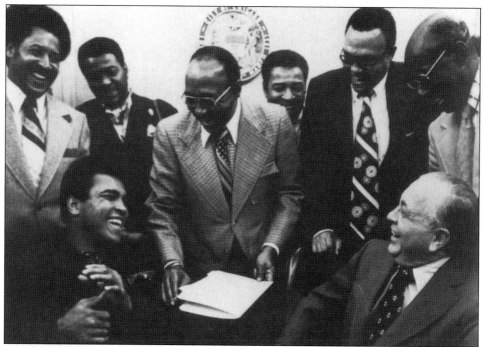

Boxer Muhammad Ali is made an honorary Chicago citizen by Mayor Daley. (Courtesy City of Chicago.) (*A View from Chicago's City Hall*)

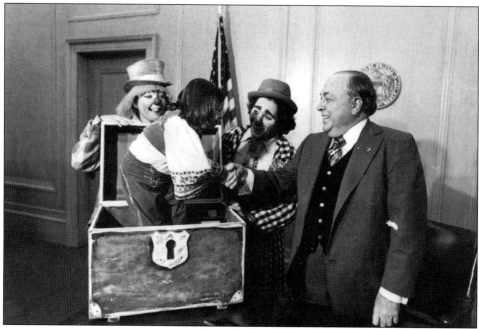

Mayor Daley's legendary sense of humor shines through as he welcomes members of the visiting Ringling Brothers Circus to his office. (Courtesy City of Chicago, Graphics and Reproduction Center.) (*A View from Chicago's City Hall*)

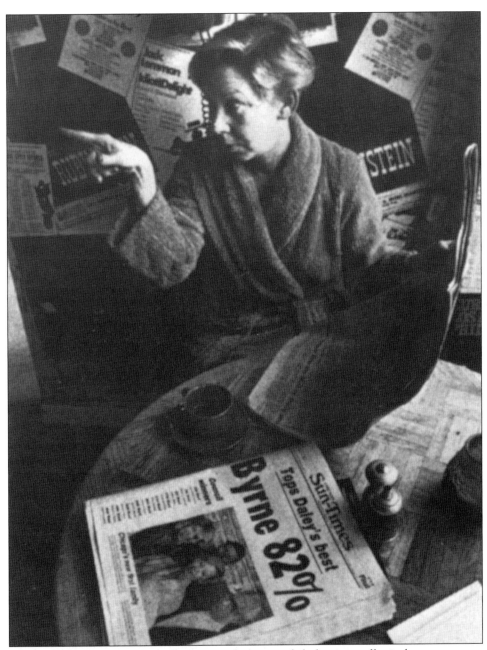

Mayor-elect Jane Byrne savors her mayoral victory while having coffee in her apartment. Her general election plurality of 82 percent exceeded even Richard J. Daley's masterful wins; it was the largest recorded by any 20th-century Chicago Democratic mayoral winner. (Courtesy *Chicago Sun-Times*.) (*A View from Chicago's City Hall*)

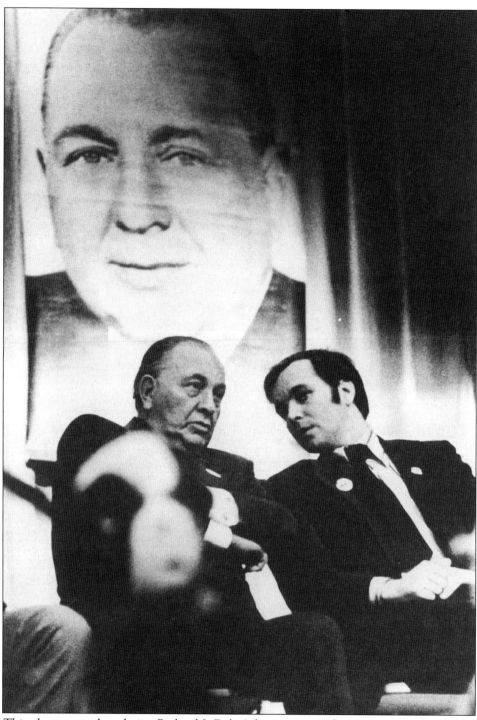

This photo was taken during Richard J. Daley's last campaign for mayor in 1975. Old pro Daley took great pride in his son's career as an Illinois state senator. (Courtesy Office of the Mayor.) (*A View from Chicago's City Hall*)

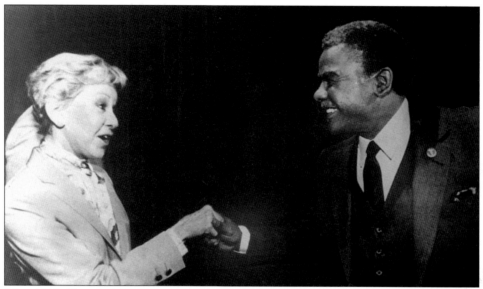

The 1983 Chicago Democratic mayoral primary was the city's political "Super Bowl." Never in Chicago's political past was there a more competitive and brutal fight for power. This ultimate battle was easily the most expensive mayoral contest in history, it had the highest primary turnout and gave Chicago wall-to-wall campaign politics for over three months. This photo shows incumbent Jane Byrne gingerly greeting one of her opponents, Congressman Harold Washington, prior to the campaign's first debate. The third major candidate in this race was then Cook County States Attorney Richard M. Daley. (Courtesy *Chicago Sun-Times*.) (*A View from Chicago's City Hall*)

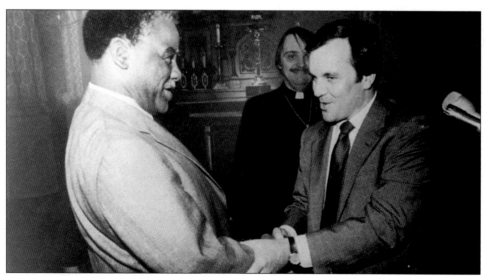

In late January, as the three-way Democratic mayoral campaign became emotionally charged, States Attorney Daley and U.S. Congressman Washington attempted to defuse racial feelings in a joint rally held at the First Lutheran Church, which was located on Daley's home turf, in the Bridgeport neighborhood. (Courtesy *Chicago Sun-Times*.) (*A View from Chicago's City Hall*)

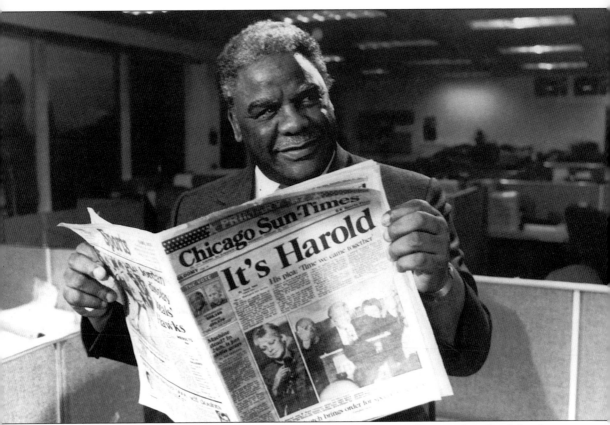

Harold Washington holds up the *Chicago Sun-Times* following his hard-fought 1987 Democratic mayoral primary win against former Mayor Jane Byrne. (Courtesy *Chicago Sun-Times*.) (*A View from Chicago's City Hall*)

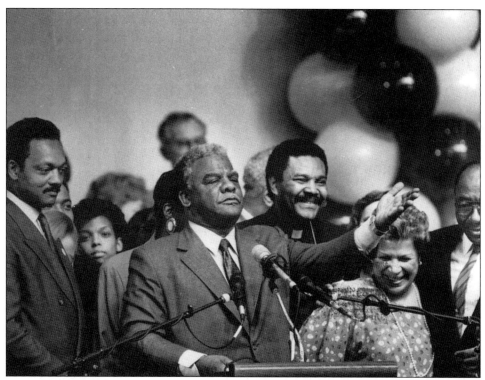

Harold Washington claims victory in the 1987 mayoral primary, surrounded by three important supporters. They are, from left to right, as follows: Rev. Jesse Jackson, Rev. B. Herbert Martin (his pastor), and City Treasurer Cecil Partee. (Courtesy *Chicago Sun-Times*.) (*A View from Chicago's City Hall*)

Richard J. Daley loved to lead the city's St. Patrick's Day parade. He is shown here marching in the 1974 parade, flanked on his right by movie stars Chuck Conners and Forrest Tucker. On his left are political and civic leaders Ed Brabec (parade chairman), Police Superintendent James Rochford, and Lt. Gov. Neil Hartigan. Parades have played a huge role in Chicago's overall political scene and have been an accurate barometer of political leadership and changing city demographics. (Courtesy Holime Collection.) (*A View from Chicago's City Hall*)

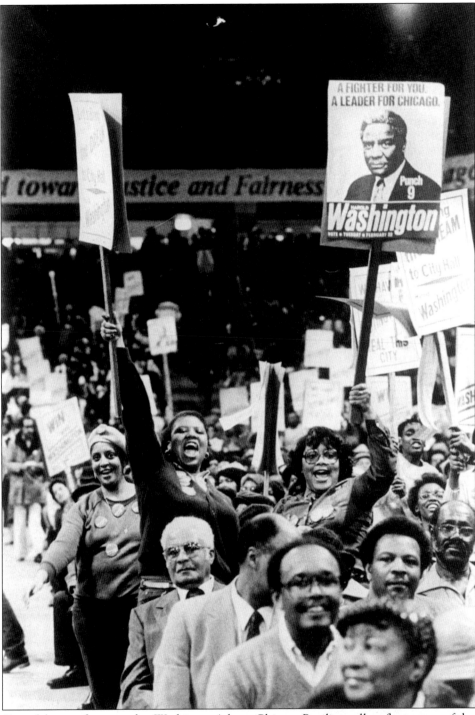

Part of the overflow crowd at Washington's huge Chicago Pavilion rally reflects some of the religious-political fervor during the spring of 1983 that turned the campaign into a "Black crusade." (Courtesy *Chicago Sun-Times*.) (*A View from Chicago's City Hall*)

Richard J. Daley, "America's last boss," exuded a twinkling Irish charm, even though he was somewhat flustered by an affectionate Hawaiian tourist representative. (University of Illinois at Chicago Library, Department of Special Collections.) (*A View from Chicago's City Hall*)

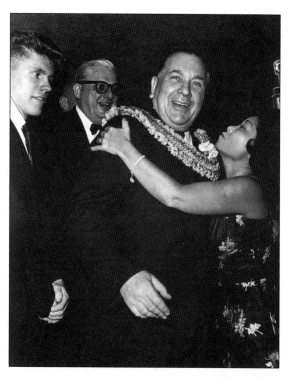

Historically, Chicago's elevated train and bus lines have been critical to the city's economy. Most Chicago mayors have been very pro public transportation. Seen here is Mayor Richard Daley cutting the ceremonial ribbon, opening one of the city's renovated elevated and subway train lines. (Courtesy City of Chicago, Graphics and Reproduction Center.) (*A View from Chicago's City Hall*)

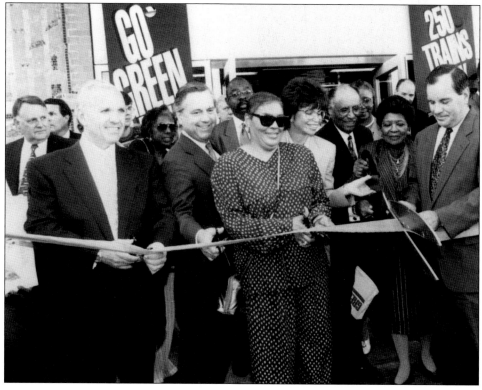

117

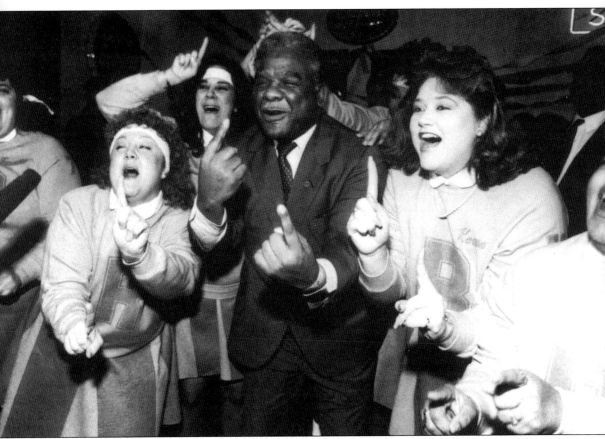

Mayor Washington celebrates the Chicago Bears' 1986 Super Bowl victory with the "Refrigerettes." These somewhat beefy cheerleaders were named in honor of the Bears' heaviest player William "The Refrigerator" Perry. (Courtesy City of Chicago.) (*A View from Chicago's City Hall*)

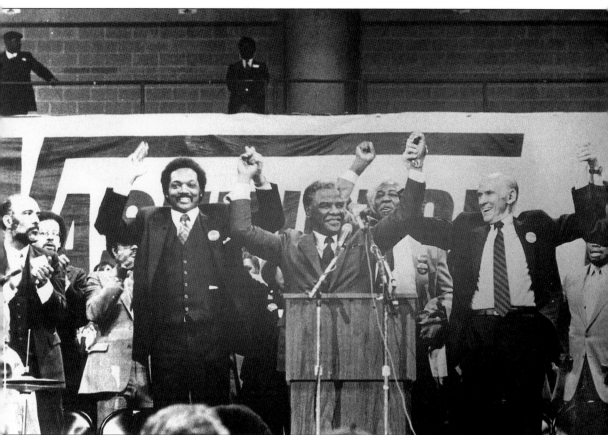

Candidate Harold Washington (center) celebrates his February 1983 mayoral primary victory with Jesse Jackson (left) and Senator Alan Cranston of California. (Courtesy University of Illinois at Chicago.) (*A View from Chicago's City Hall*)

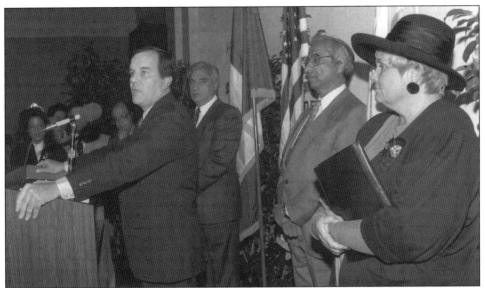

Chinese-American caterers invite Mayor Richard M. Daley to taste cuisine from their homeland during the Chinese New Year Celebration held at Truman College on 1145 West Wilson Street. During the event, which was sponsored by the Chinese Mutual Aid Association (CMA), Mayor Daley said, "This celebration reflects the great spirit, warmth and cooperation that exists between all of Chicago's diverse cultures. I'd like to thank our Asian-American community for contributing to Chicago's cultural richness." Greeting the mayor upon his arrival was Raymond Tu, CMA board president; Bart Moy of the Commission on Asian-American Affairs; and the mayor's close ally, Kathy Ostermann, director of the Mayor's Office of Special Events. (Courtesy Holime Collection.) (*A View from Chicago's City Hall*)

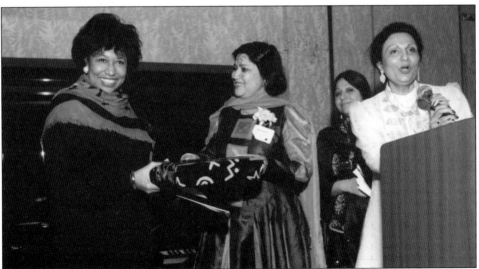

Officers of the Club of Indian Women present a gift to Illinois Democrat Senator Carol Moseley Braun at their annual dinner banquet in 1993. Braun was the first African-American woman to be elected to the U.S. Senate. (Courtesy Holime Collection.) (*A View from Chicago's City Hall*)

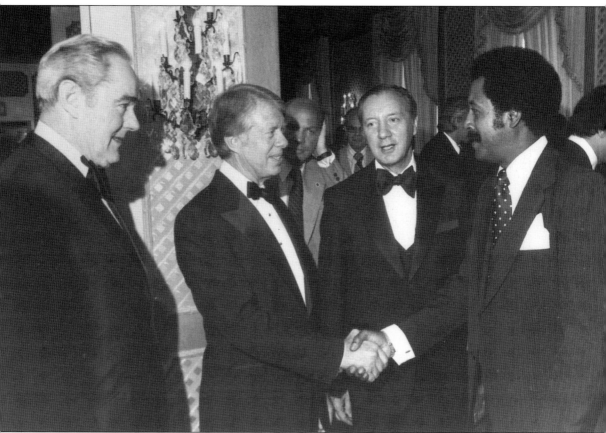

President Jimmy Carter joined Mayor Bilandic at a Democratic Party fundraiser in Chicago. Standing beside Carter is George Dunne, chairman of the Cook County Democratic Party and president of the Cook County Board of Commissioners. Dunne had a cool relationship with the new mayor. Also standing beside Bilandic is Alderman Eugene Sawyer, the man who would become mayor of Chicago following Harold Washington's death in 1987. (Courtesy City of Chicago Graphics and Reproduction Center.) (*A View from Chicago's City Hall*)

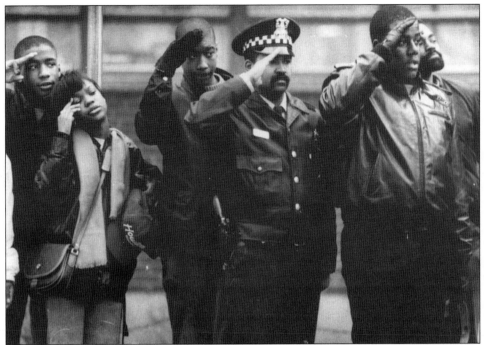

Mourners salute the solemn funeral procession of Harold Washington, Chicago's first black mayor, in 1987. (Courtesy *Chicago Sun-Times*.) (*A View from Chicago's City Hall*)

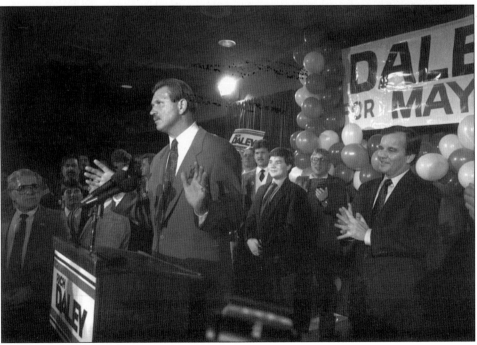

Mike Ditka, former coach of the Chicago Bears, is seen here at his well-known restaurant endorsing Richard M. Daley. (Courtesy *Chicago Sun-Times*.) (*A View from Chicago's City Hall*)

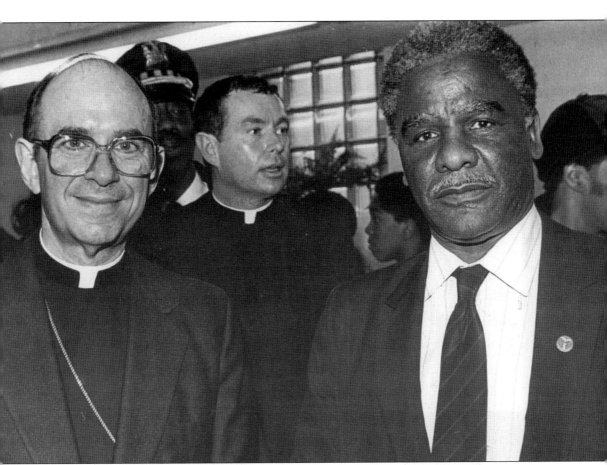

Healing the wounds in a very Catholic city, mayoral winner Harold Washington visits with Chicago's prince of the church, Joseph Cardinal Bernardin. (Courtesy Al Cato.) (*A View from Chicago's City Hall*)

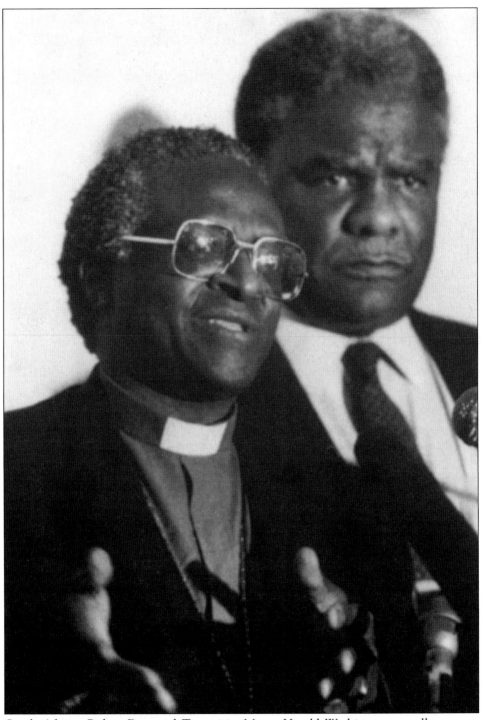

South African Bishop Desmond Tutu visits Mayor Harold Washington to rally support against South African apartheid policies. (Courtesy Office of the Mayor.) (*A View from Chicago's City Hall*)

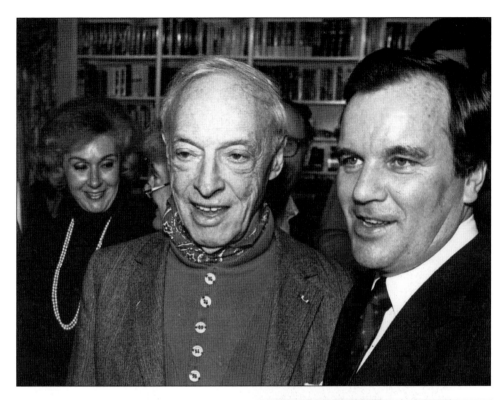

One of the keys to Rich Daley's successful 1989 campaign was his ability to win the support of prominent lakeshore liberals and independents. At a Hyde Park function, Daley posed with his strong supporter, Nobel Prize-winning author Saul Bellow. (Courtesy Office of the Mayor.) (*A View from Chicago's City Hall*)

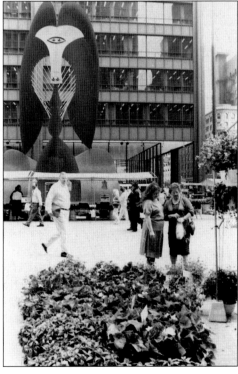

Chicago's famous outdoor Picasso Statue is located in the downtown Richard J. Daley Plaza. Though known nationally as a city of broad shoulders and bare-knuckle politics, Chicago is also a world-class city rich in architecture and art. All Chicago mayors have endorsed and played up the city's grand cultural tradition. (Courtesy City of Chicago, Graphics and Reproduction Center.) (*A View from Chicago's City Hall*)

125

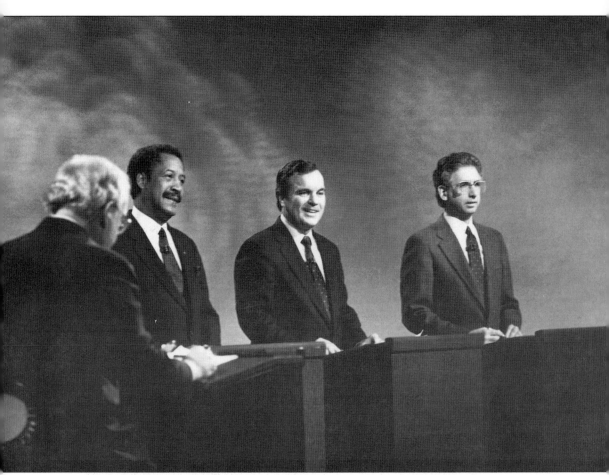

The only televised debate among the 1989 Democratic mayoral primary candidates found Richard M. Daley performing better than expected. The participants, from left to right, included moderator John Callaway of WTTW-TV (back to camera) and candidates Eugene Sawyer, Richard M. Daley, and Lawrence Bloom. (Courtesy *Chicago Sun-Times.*) (*A View from Chicago's City Hall*)

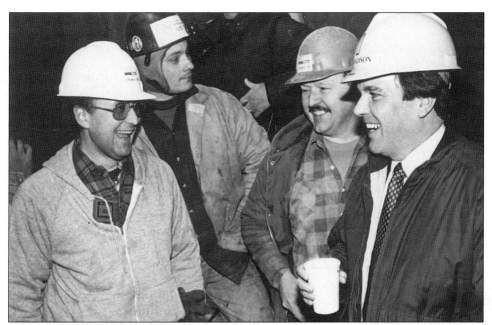

"Builder" Mayor Richard M. Daley is seen here at ground level talking with the "real" builders, construction workers at a Chicago hotel re-development project. (Courtesy Office of the Mayor.) (*A View from Chicago's City Hall*)

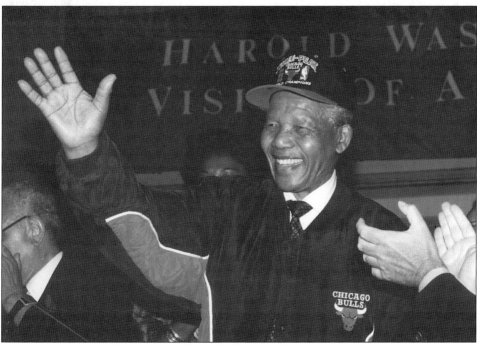

South African President Nelson Mandela was given a huge citywide reception as well as a Chicago Bulls jacket and hat during his brief visit to the city. (Courtesy Rosalie Clark Collection.) (*A View from Chicago's City Hall*)

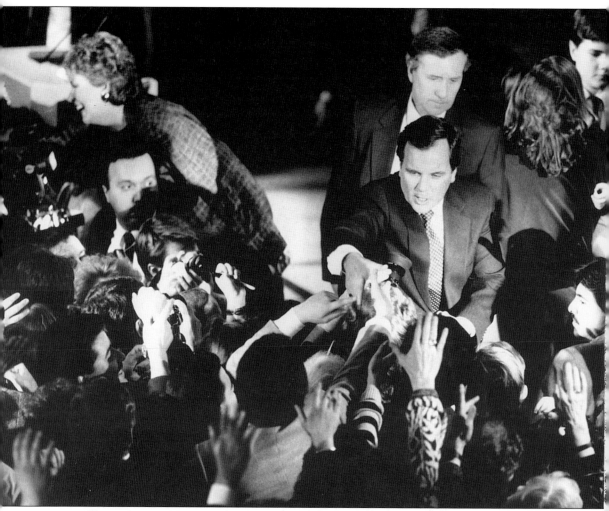

Chicago's new mayor, Richard M. Daley, greets supporters on election night in 1989. Mrs. Daley (top left) is in high spirits after the long, successful campaign. (Courtesy *Chicago Sun-Times.*) (*A View from Chicago's City Hall*)